WILDLIFE PAINTING
STEP BY STEP

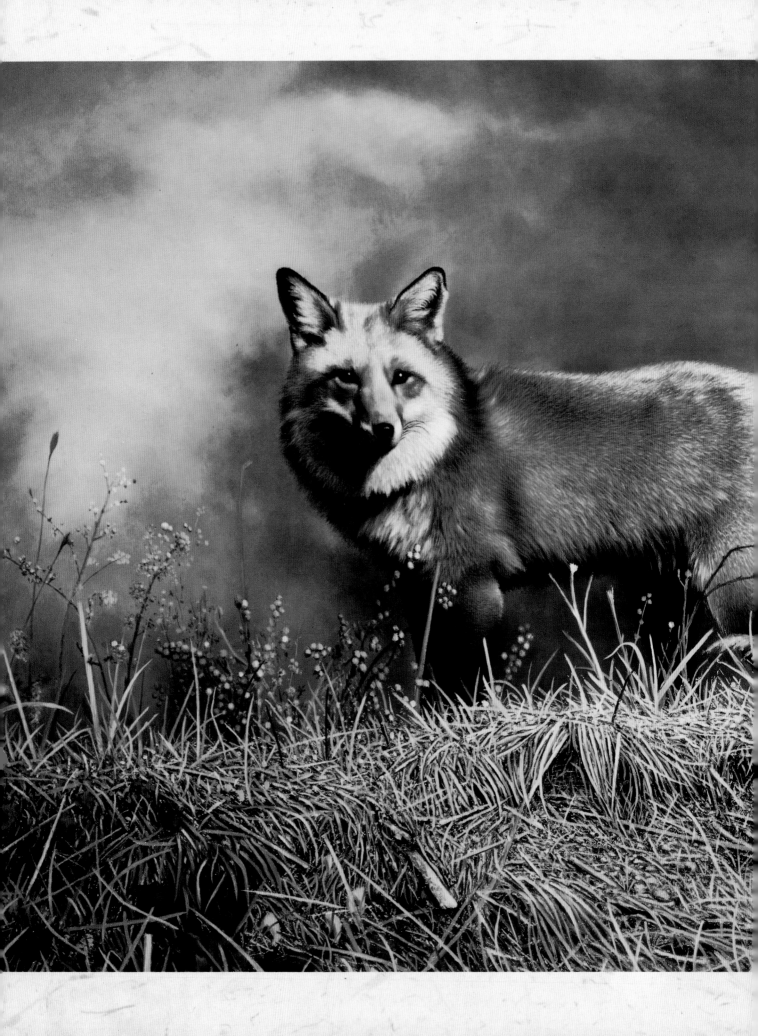

WILDLIFE PAINTING
STEP BY STEP

PATRICK SESLAR

With a Forward by Robert Koenke,
Editor, *Wildlife Art News*

NORTH LIGHT BOOKS
CINCINNATI, OHIO
www.artistsnetwork.com

Red Rascal, Charles Fracé, Oil, 19″ × 24″

Other fine North Light Books are available from your local bookstore, art supply store or direct from the publisher.

10 09 08 07 06 10 9 8 7 6

Library of Congress has catalogued hard copy edition as follows:

Seslar, Patrick
 Wildlife painting step by step / by Patrick Seslar.—1st ed.
 p. cm.
 Includes index.
 ISBN-13: 978-0-89134-584-8 (hardcover)
 ISBN-10: 0-89134-584-1 (hardcover)
 1. Wildlife art. 2. Painting—Technique. I. Title.
ND1380.S46 1995
751.4—dc20
ISBN-13: 978-1-58180-086-9 (pbk: alk paper) 95-1799
ISBN-10: 1-58180-086-X (pbk: alk paper) CIP

Edited by Rachel Wolf and Kathy Kipp
Cover and interior design by Sandy Conopeotis Kent

METRIC CONVERSION CHART		
TO CONVERT	**TO**	**MULTIPLY BY**
Inches	Centimeters	2.54
Centimeters	Inches	0.4
Feet	Centimeters	30.5
Centimeters	Feet	0.03
Yards	Meters	0.9
Meters	Yards	1.1
Sq. Inches	Sq. Centimeters	6.45
Sq. Centimeters	Sq. Inches	0.16
Sq. Feet	Sq. Meters	0.09
Sq. Meters	Sq. Feet	10.8
Sq. Yards	Sq. Meters	0.8
Sq. Meters	Sq. Yards	1.2
Pounds	Kilograms	0.45
Kilograms	Pounds	2.2
Ounces	Grams	28.4
Grams	Ounces	0.04

ABOUT THE AUTHOR

PATRICK SESLAR

A graduate of Purdue University, Patrick Seslar has served as a Contributing Editor for *The Artist's Magazine* for over ten years during which time he has written over seventy articles on art technique and art marketing. He co-authored *Painting Nature's Peaceful Places* (North Light Books, 1993) with Robert Reynolds. Mr. Seslar's monthly column of travel and humor was a regular feature in *Trailer Life* magazine for several years and his writings have been published in numerous national magazines including *American West, Backpacker, Personal Computing,* and *Motorhome.* Mr. Seslar is listed in *Who's Who in U.S. Poets, Editors and Authors.*

Mr. Seslar is also an accomplished artist. Along with twenty other artists, his life and work are profiled in *Being an Artist* (North Light Books, 1992). His paintings have been exhibited in galleries across the country and have appeared in numerous national magazines and newspapers including *The Artist's Magazine, Trailer Life, The Los Angeles Times* and the *Miami Herald.*

ACKNOWLEDGMENTS

I offer my most heartfelt thanks to each of the artists who so generously contributed their time and talent to make this book possible.

Thanks, too, to Robert Koenke, editor and publisher of *Wildlife Art News,* for providing me with a virtual color catalog of all the best in wildlife art via a complete set of back issues, for his assistance and suggestions, and most of all, for taking time out of a demanding schedule to write a thoughtful and perceptive foreword for this book.

My thanks as well to Sara Koller and Vicki Schmidt of Wild Wings, Inc. (Lake City, Minnesota) for putting me in touch with Randall Scott, Mark Susinno and Persis Weirs, and for their promptness in providing much-needed transparencies of those artists' work.

Last but hardly least, I deeply appreciate the efforts of everyone involved at North Light Books who worked on this book and most especially, Acquisitions Editor Rachel Wolf, who shaped the concept and had the confidence to allow me to bring it to fruition.

5

TECHNIQUES FOR PAINTING TEXTURES

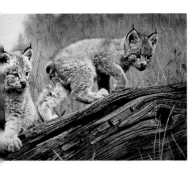

Painting the Textures of Fur, 52

• The Two Textures of Wolf Fur • Rendering Wet Fur on Aquatic Mammals • Capturing the Play of Light of White Fur

Mastering the Anatomy of Wings and Feathers, 64

• Anatomy of a Wing • Anatomy of a Feather

• Painting Wings and Feathers

Aquatic Textures: Scales and Iridescence, 74

• Scales • Iridescence

6

PAINTING WILDLIFE STEP-BY-STEP

FOREWORD

When Pat Seslar asked me to write a foreword to *Wildlife Painting*, I was thrilled with the opportunity to speak to the many readers who would review and utilize this book in their continuing education of learning skills from today's wildlife masters. Active in wildlife art for more than twenty-five years, it has been my pleasure to know and observe, as well as to judge, many of the competitions in wildlife art and encourage many artists through marketing seminars throughout the world. Similar questions continue to be asked in these discussions.

Probably the most commonly asked question by a beginning artist is, "How do I improve my work?" While a complex question, an artist must search not only for his own talents, but observe keenly those who have been successful and develop his own skills and communication with his viewers. What makes one artist great will not make another great. While some artists are successful in painting details, others concentrate on animal gestures, accuracy in habitats, backgrounds, anatomy, or in the essence of the animal. I personally feel that the artist must be true to himself in developing these skills and also be a keen observer of nature. To me, the observation and research that goes into a good painting is essential.

I'm often chagrined to hear many artists say they don't enjoy the research that goes into their work. To me, the research is the most important aspect of completing a good painting. Given that the artist has the skills, which this book discusses, the research behind a painting provides essential information on the gestures and anatomy of wildlife subjects. Artists must go beyond the barrier of being just a "painter." They must be emotionally involved with their subjects and their painting. They must also ask whether they want to paint for the market (most popular subject syndrome) or balance their art by creating from within (the artistry which compels the artist): there remains a big difference. Many artists do paint popular subjects for the more commercial limited edition print market, but those who are successful also paint for themselves because they wish either to convey a message or develop painterly skills.

A successful artist must also be a keen marketer and observer of the opportunities available in the marketplace. It's a lot of work to balance—being an artist, marketing your work, and being a good, prudent businessperson. When each of these three aspects are balanced successfully the equation is success. The artist who completes fine paintings but doesn't have a successful marketing program and isn't attuned to good business practices, will not be successful. It's unfortunate that I see so many artists stymied by this simple equation. Quite commonly, the artist finds that a spouse, friends or other supporters can fill in gaps where he is unsuccessful or unskilled in these important functions.

The artist also must be a keen observer of nature. The public has become much more attuned to strong artistic endeavor versus the mediocre. Skills and technique provide the artist the ability to complete a work which can communicate to the public. However, if the subject isn't anatomically correct, or its gestures or habitat are incorrect, the painting has failed in this. Good art takes a tremendous amount of work, and the basic artistic skills of composition, mood, texture, and design all remain essential to completing a good piece of art.

Observe carefully the masters that are included in this book and how each has achieved and used these skills. They remain ultimately important to your success as an artist in this field.

The public's enthusiasm about wildlife art shouldn't come as a surprise to artists today. It has become popular because it appeals directly to the masses. It was never promoted by Madison Avenue or by art critics. The public could observe, understand and enjoy the art directly; it doesn't need interpreters, nor does it need a museum director saying, "This is fine art." Wildlife art has always been maligned because of its end-run and many criticize it because animals don't necessarily grab their fancy.

But wildlife art has been embraced by the masses. The number of shows and exhibitions across the United States and the world continues to prosper. It's exciting that the challenges of wildlife art are something that people can simply relate to and enjoy. No art critic needed here.

The U.S. Department of Interior noted several years ago that the interest in wildlife—specifically non-consumptive use of wildlife (non-hunters)—consisted of 109.6 million adult Americans, nearly one in two. The report defined these people as "those who observe, photograph or feed wildlife." If these nearly 110 million Americans enjoy the subject, you can imagine the potential market that remains untapped for nature and wildlife art. Wildlife art is the people's art. With the tremendous heritage of the United States and its wildlife and the growing interest in endangered and exotic species, wildlife remains the most popular form of art today. At one time, I estimated that the market of related limited edition prints, originals and shows would be over a two billion dollar industry. Critics may argue that the art form is too commercial, but even the finest masterworks, such as the Mona Lisa, have been bastardized onto pencils, pens and T-shirts. I continue to argue that the discussion is mute.

It is with great pleasure I welcome you to *Wildlife Painting Step by Step*. I challenge you to become involved in this exciting art genre. The world is your stage and nature's wonders are your players. Enjoy what you are doing in this art form and your audience won't be disappointed.

Robert J. Koenke
August 1994

INTRODUCTION

Perhaps more than any other segment of the current art scene, wildlife art is a product of the passionate concerns of the artist. A "successful" wildlife painting reflects the personalized sum of its creator's ecological concerns and attention to certain wildlife species, as well as favorite color schemes, compositional structures and working methods, including choice of medium. With all these factors to consider, it is my hope that this book will provide you with some keys that will broaden your skills and enrich your excitement about the fascinating range of wildlife subjects that are open to you in the sea, on land and in the air.

In the first half of this book, you'll see how to develop your own wildlife interests and style by focusing on wildlife species that have personal significance for you, and where to get reference materials. And, since the ideal subject and setting rarely coexist in nature, you'll learn several ways to select, create and paint realistic habitats. You'll also find out a number of useful ways professional wildlife artists place wildlife subjects in their compositions. Finally, you'll learn techniques that will allow you to create the textures of wings and feathers; fur; and the iridescence of fish scales.

In the second part of the book, you'll look over the shoulders of twelve top wildlife artists as they go about creating their imagery. Each demonstration explores a different facet of the painting process and reveals techniques and ways of thinking you'll find enlightening and useful, such as:

- how to develop a composition intuitively or on the basis of an abstract design
- how to paint wildlife in complex backgrounds
- how to combine animals and landscapes
- how to emphasize details with loose brushwork

Finally, you'll meet the artists who have so generously contributed work and commentary to this book. You'll discover that several of them literally have a lifetime of experience painting wildlife while others have only a few years. I urge you to begin with the artists' biographies so that you can "put a face" with their comments as you read through this book. You'll also discover that they're real, down-to-earth people who share a common commitment to wildlife and its preservation through their art.

At the back of the book you'll find a resource list with addresses and phone numbers (where applicable) for a number of useful publications as well as a potpourri of artists' and wildlife organizations that can provide valuable assistance and help speed you on your way to becoming a more accomplished wildlife artist.

Patrick Seslar
La Jolla, California

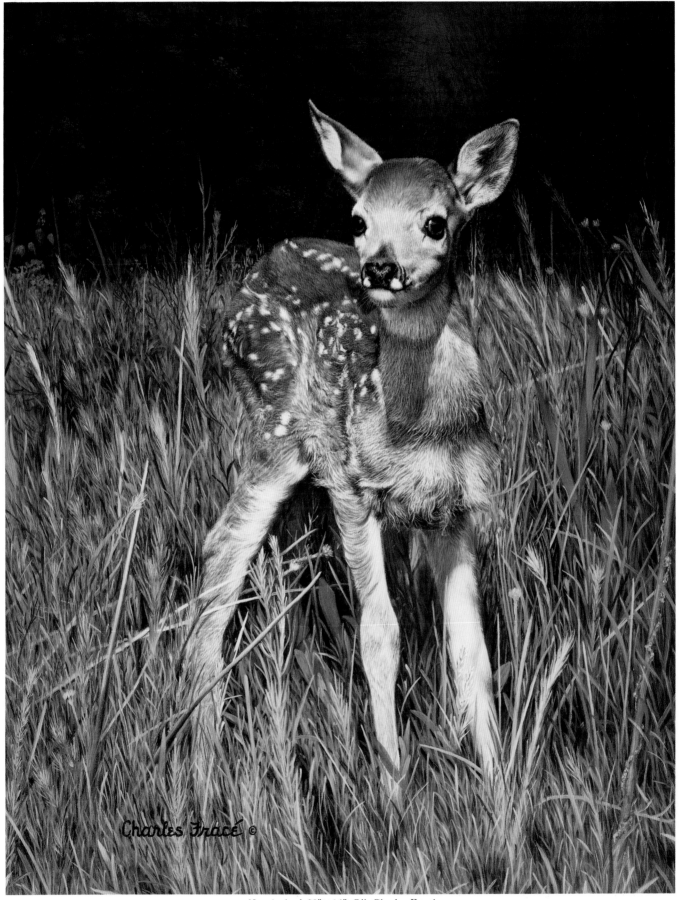

New Arrival, 20″ × 16″, Oil, Charles Fracé

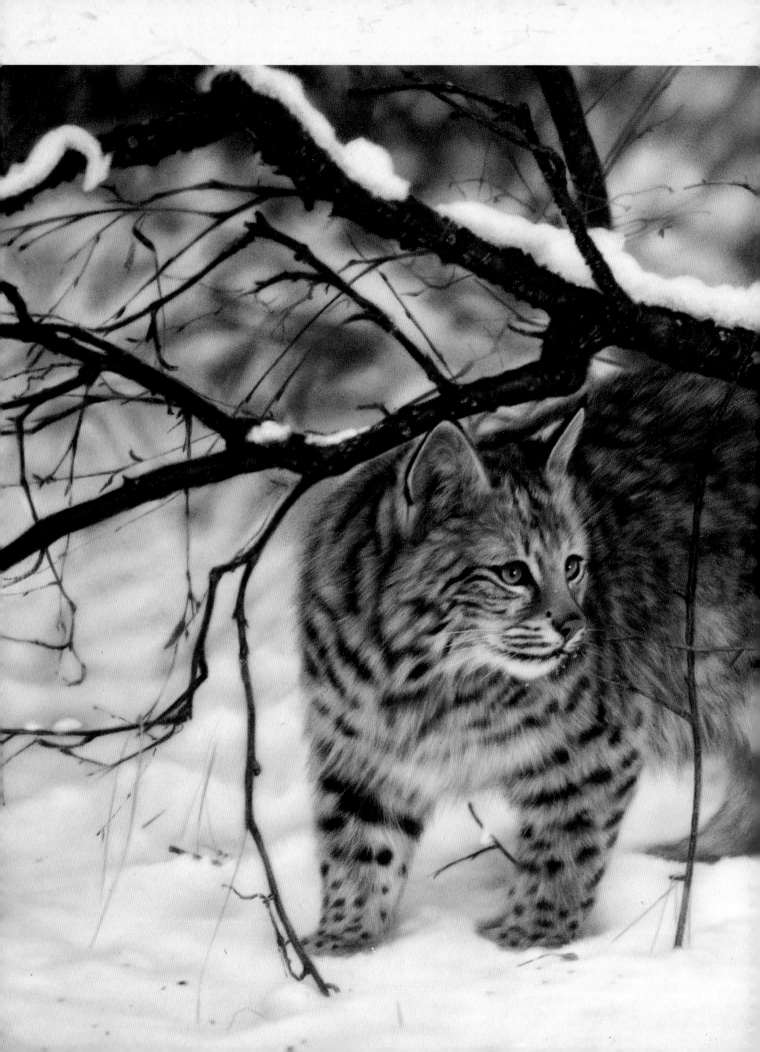

1

CHOOSING A SUBJECT

There are many things to consider when choosing which wildlife subjects to paint. Generally, however, your choices will be determined by four basic factors:

1. Accessibility
2. Lifelong Interests
3. Environmental Concerns
4. Marketability

Naturally, nothing is simply "black or white," and as most professional wildlife artists will candidly admit, the choice of subjects must ultimately reflect influences from each of these factors to a greater or lesser degree. In this chapter we'll take a closer look at each of them in turn.

Step Softly, 18″ × 24″
Pastel
Lesley Harrison

ACCESSIBILITY

Most wildlife artists agree that you need firsthand knowledge to paint any wildlife subject credibly. Therefore it is very practical to focus on wildlife that can be found within a few days' drive or a few hours' flight from your home. The benefit is obvious: Your artistic skills will grow more rapidly when you are able to observe and paint your subjects more easily and more often. Furthermore, by working with wildlife that can be observed and painted in its natural habitat, you're far more likely to produce images that resound with the freshness and authenticity born of firsthand experience rather than succumbing to stale reiterations of widely circulated photographs and paintings by others.

The next chapter (and the section on "Wildlife Organizations and Publications" at the end of the book) provides useful hints on how to discover and mine the wealth of wildlife that's to be found not far from home. However, choosing wildlife species because they're accessible doesn't mean you'll be limiting your subject matter. An amazing diversity of wildlife can be found not far from your door. Too often, we define "wild-

life" rather narrowly when, in fact, every living thing is a potential subject. In addition to the songbirds that can be glimpsed out a window, the artists who have contributed their work and words to this book have found a range of intriguing subjects within hours of their homes, from birds of prey to wolves, bears, game fish and ocean dwellers such as dolphins, whales and seals.

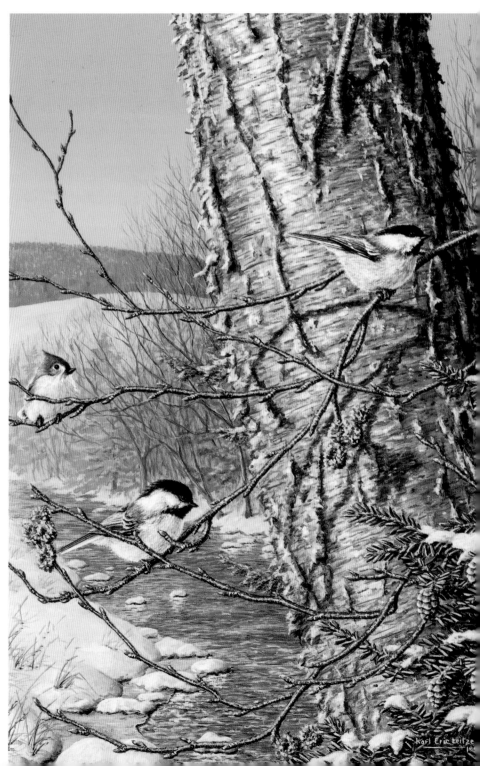

OBSERVE SPECIES IN THE WILD. "Most of my subjects are native to the northern Appalachians in Pennsylvania where I live because I prefer painting species I've been able to observe in the wild," says Leitzel.

Just Passing Through, 22½″ × 15″
(Black-capped Chickadees and Tufted Titmouse)
Acrylic, Karl Eric Leitzel

Purple Gallinule in the Everglades, 20″ × 24″
Acrylic, Bart Rulon
Collection of Dr. Norman B. Roland

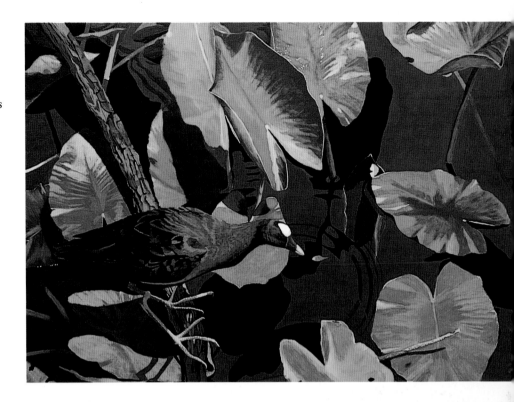

ACCESSIBLE BIRDS. "When I was younger," says Bart Rulon, "I spent lots of time fishing with my Dad. That gave me time for birdwatching; the wildlife I saw there inspired my earliest drawings and paintings. Today, I specialize mainly in birds that frequent lakes, streams and marshes because I still love the aquatic environment and because birds are more accessible than mammals."

A MOVE TO BIG-HORN COUNTRY
For Enright, a childhood fascination with wildlife was delayed until later in life when he moved to Colorado. "I had the opportunity to observe and paint Rocky Mountain bighorn sheep on a regular basis and that rekindled my desire to paint wildlife."

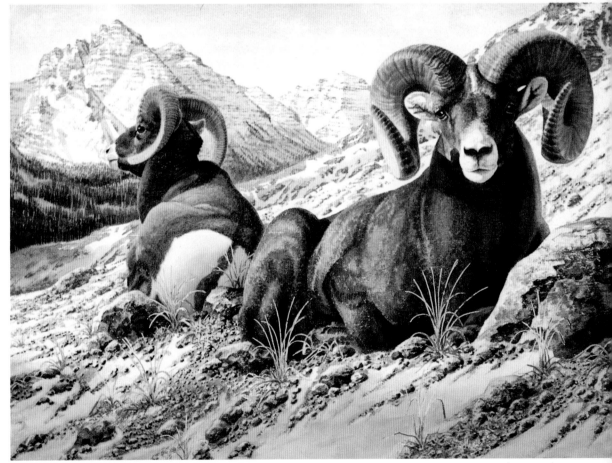

At Rest But Alert, 22″ × 30″ (Bighorn Sheep), Watercolor, Don Enright

LIFELONG INTERESTS

For many artists, the choice of wildlife subjects evolves from childhood experiences. The drive to paint certain wildlife is often fueled by enthusiasm for subjects that an artist knows and loves. For Randall Scott, an interest in diving and access to an ocean teeming with watery wildlife led to his area of specialization; for Mark Susinno, a brother's interest in fishing led to his enthusiasm for the sport and its art; for Persis Weirs and Lesley Harrison, a love of horses has broadened to encompass many other wildlife species.

Sea Fans, 23″ × 36″
Acrylic, Randall Scott
Courtesy of the artist and Wild Wings, Inc.

TV SPARKS WILDLIFE INTEREST. Randall Scott's interest in wildlife art grew from watching television programs such as *Sea Hunt* and the various Jacques Cousteau specials. "At an early age," he says, "I began snorkeling and scuba diving. I've always been interested in drawing and painting subjects that were different from the mainstream, and so, what began as a hunt for fish with a spear gun quickly became a hunt for them with an underwater camera and my canvases."

Cornered—Striped Bass, 20″ × 32″
Acrylic, Mark Susinno
Courtesy of the artist and Wild Wings, Inc.

AN INTRODUCTION TO FISHING. "My brother introduced me to bass fishing," says Susinno, "and this really ignited a passion in me for fishing. As I entered and won more trout stamp competitions, the link between my artwork and my love of fishing became inescapable."

Wild Hearts, 30″ × 45″, Acrylic, Persis Clayton Weirs
Courtesy of the artist and Wild Wings, Inc.

A LOVE OF HORSES. "As a young girl," says Weirs, "I was obsessed with horses and, growing up on a wild island in Maine, the summers afforded me many opportunities to observe and develop an interest in the native wildlife."

PAINT WHAT MOVES YOU

"I paint mostly for myself," says Harrison, "and I feel privileged to be able to make a living doing something I love so much. I paint what moves and excites me and hope that my artwork communicates that."

Dressed in New Snow, 18″ × 24″ (Mountain Lion)
Pastel, Lesley Harrison

ENVIRONMENTAL CONCERNS

It's an almost inescapable fact that, on many fronts, our environment and many species of wildlife are in jeopardy, threatened by the deliberate predation of man, by mankind's indifference to the environmental consequences of industrial and agricultural production, and by the environmental disruption associated with the extraction of natural resources. Many wildlife artists feel an ethical and moral obligation to use their talents to make the public aware of what is being lost. Quite often, these artists help raise funds to save endangered and threatened species. Artist Charles Fracé, for example, has worked for thirty years to increase public awareness of the plight of harp seals (see page 63), sea otters, koalas and other animals. Like Fracé, all of the artists featured in this book have some ongoing personal involvement with various wildlife conservation or preservation organizations.

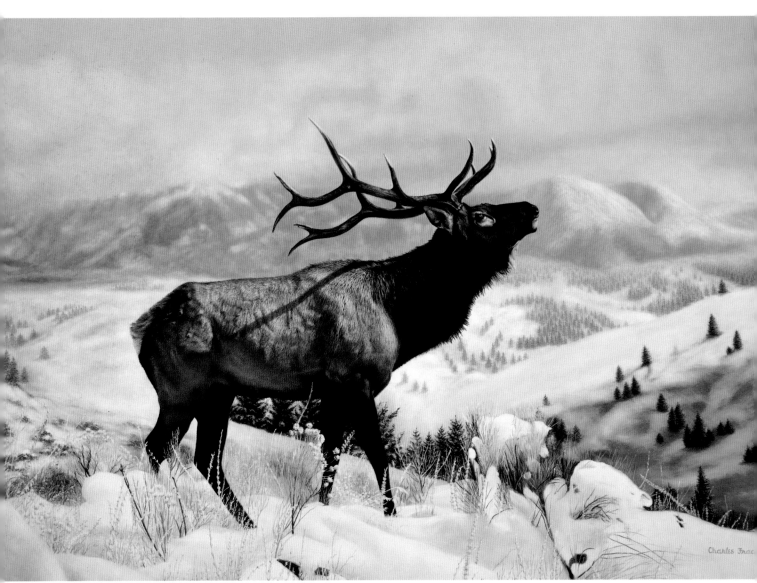

GREAT NORTH AMERICAN MAMMALS. All large mammals are threatened by the encroachment of humans into their natural environment. The American elk is no exception.

The Challenger, 22″ × 32″ (American Elk)
Oil on canvas, Charles Fracé

White Storks in Mating Display
22″ × 34″
Watercolor
David Rankin

BIODIVERSITY IN INDIA. "I specialize in the birds and wildlife of India," says Rankin. Although only one-sixth the size of North America, India is home to the second largest biodiversity of birds on the planet as well as home to lions, tigers, leopards, crocodiles, rhinos, monkeys, antelope and many species of deer."

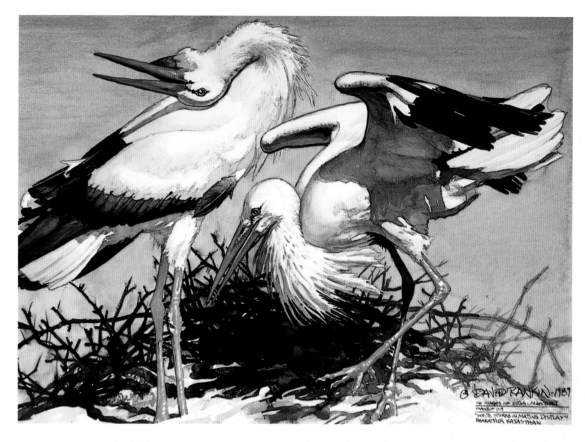

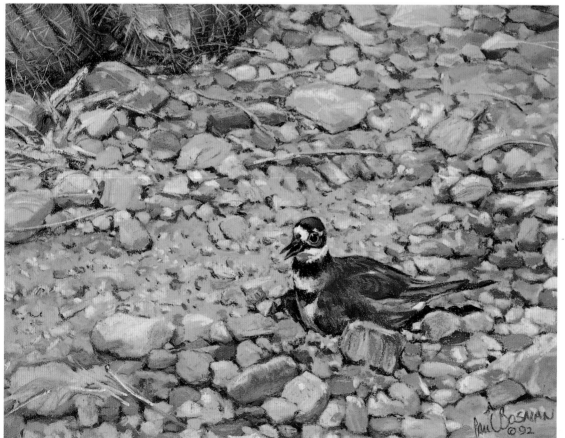

RAISING FUNDS AND CONSCIOUSNESS. Born and raised in the Great Karroo of South Africa, Bosman is no stranger to exotic wildlife. "I've been concerned with the conservation aspect of wildlife for many years," he says, "and I know the potential power of a painting. It can create an awareness of the need for conservation, as well as raise much-needed funds."

Nesting—Arizona Style, 9″ × 12″ (Killdeer) Pastel, Paul Bosman

MARKETABILITY

Simply put, you can paint whatever strikes your fancy, unabashedly paint for the market, or steer a course somewhere in between. Beyond that, you can choose to be a generalist, painting all kinds of wildlife, or specialize in one area such as songbirds, wolves, other large mammals, game fish, or undersea creatures. Much will depend on whether you need to sell your work regularly (or at all) and whether you are fortunate enough to find a niche where the subjects you love to paint mesh neatly with the public demand for wildlife art.

Each of the artists in this book has taken his or her own path. Hopefully, exploring their thoughts will help you find the path best suited to your own situation and inclinations.

A Glow in the Swamp, 20″ × 30″
(Roseate Spoonbills)
Watercolor, Luke Buck

FROM LANDSCAPES TO WADING BIRDS
"Until 1983," says Buck, "I was primarily a landscape painter, occasionally painting the deer or birds from my local area. But after a tour of Florida and my introduction to its beautiful wading birds, I became fascinated with them. They've opened up a whole new market for my work and have compounded my interest in painting all wildlife."

Myakka Whitetails, 36″ × 48″
Oil, D. "Rusty" Rust

PAINTING FOR THE MARKET. "My selection of wildlife subject matter," says Rust, "is based on the popularity of the animal and whether the market is responding favorably to it. Since I'm a professional, relying on sales, I must think that way. In addition, a good percentage of my images are suggested by a collector's plate company that also has a feel for the market."

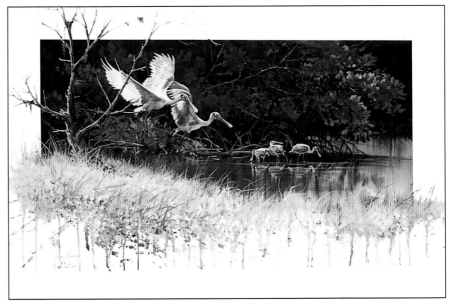

Pileated Woodpeckers
24″ × 18″
Acrylic
Danny O'Driscoll

LIMITED-EDITION PRINTS. "I participate in art shows all across the country," says O'Driscoll, "and certain subjects definitely sell better than others. If I find myself having to paint a certain bird several times, then I consider a signed and numbered limited-edition print. That way I can accommodate the market but still paint for myself."

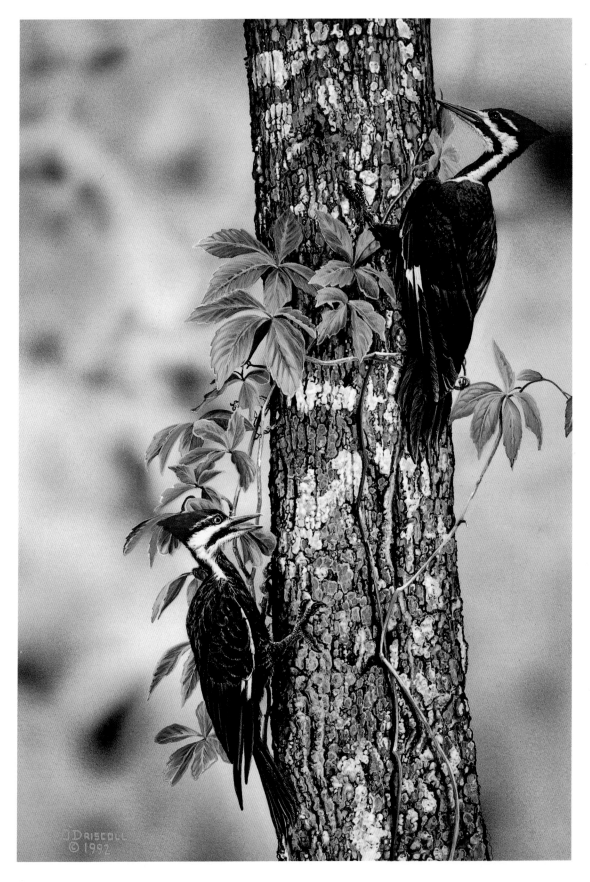

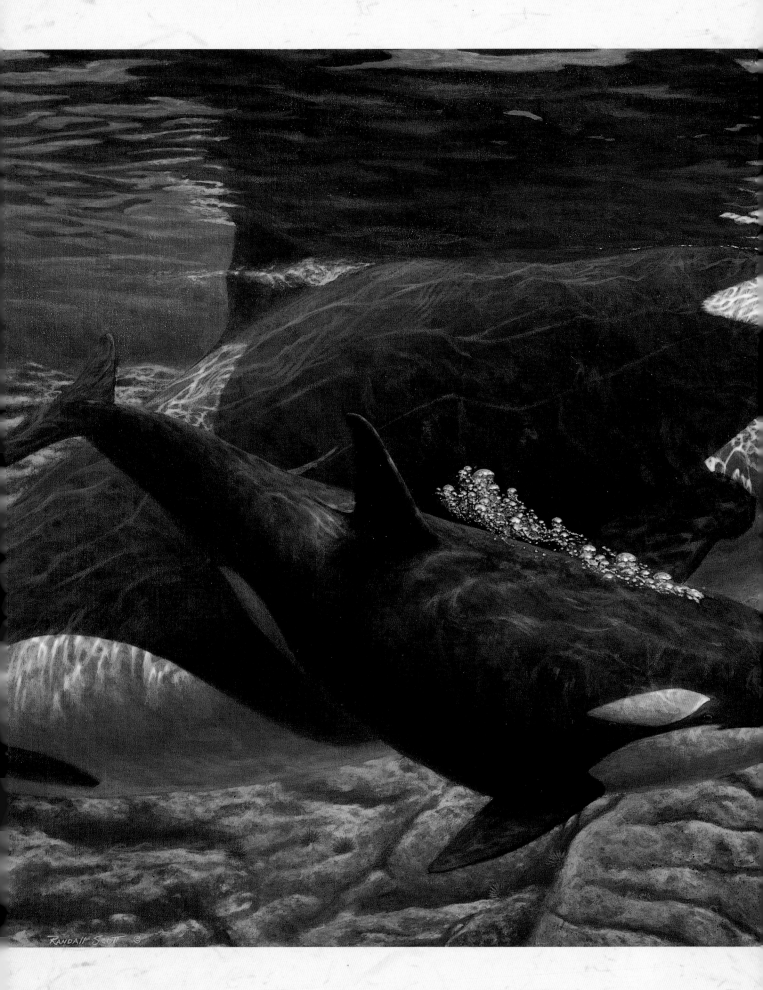

Randall Scot ©

2
COLLECTING REFERENCE MATERIALS

Once you've decided on the kinds of wildlife you'll paint, the next step is to begin assembling reference materials. Ideally, many of these will be sketches or photographs obtained through firsthand observation of an animal in its natural habitat. Of course, if the "wilds" aren't close at hand, you can usually find willing subjects in zoos, refuges and animal rehabilitation centers. Finally, your firsthand observations can be supplemented with information gleaned from various published materials including wildlife books, magazines and videos.

Section IV, "Wildlife Organizations and Publications," at the end of this book lists addresses for many different sources of reference materials. Meanwhile, in this chapter we'll talk about some pros, cons, and thoughts about each type of reference.

Shoreline Procession, 22" × 36", Acrylic, Randall Scott

FIELD SKETCHES

For some strange reason, tramping through snake-infested wilds and fighting off swarms of tsetse flies while you sketch for hours on end may not have the appeal it once had. As a result, many contemporary wildlife artists rely on photography to augment their field sketches. Karl Leitzel says, "If I have a good subject in front of me, I can shoot several rolls of film in the time it takes me to complete one useful sketch." Paul Bosman agrees, "Sketching is an important part of painting, but it isn't always practical in the wilds unless it's the habitat itself you're sketching."

Despite the undisputed ease and speed of collecting references photographically, the value of field sketching shouldn't be overlooked. Field sketches are a wildlife artist's most effective tool for crystallizing innumerable firsthand observations of wildlife subjects and for distilling what is essential from a vast array of postures, behaviors and details of habitat. By comparison, a photograph represents at most the limited knowledge contained in a single frame from a feature-length wildlife film.

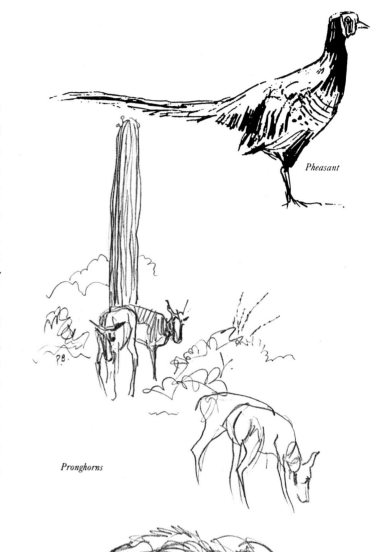

Pheasant

Pronghorns

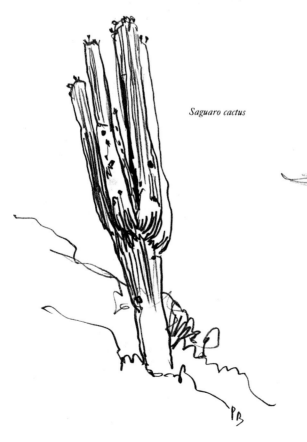

Saguaro cactus

Gambel's quail

PAUL BOSMAN'S FIELD SKETCHES. These drawings by Paul Bosman exemplify the range and diversity of information he collects via field sketches. Most took only a few minutes and were completed either from life or from slides he took of captive animals at various rehabilitation, research and zoological facilities in the vicinity of Phoenix and Tuscon, Arizona. To obtain the reference for *Five O'Clock Shadow* (page 31), Bosman accompanied a wildlife researcher while he tracked and located a radio-collared desert mountain lion.

Certain sketches were of immediate use in composing paintings, while others simply provided Bosman with a more detailed picture of the rich tapestry of life that abounds in the Sonoran Desert.

For many wildlife artists, detailed sketching often takes place in the studio where reference materials can be reviewed in comfort, sanity and safety. "When I have a painting in mind," says David Rankin, "I review my reference slides to see what I have, then I go to the library, look at various books, or visit a zoo and observe. When this information gels, I begin sketching compositions in my studio until I decide what I want to do."

Randall Scott puts it this way: "If all you do is copy a photograph, your painting will be no better. A great painter gets beneath the skin of his or her subjects, giving life and purpose to the animal and its environment. To do that you have to understand your subject inside and out, almost to the point of obsession."

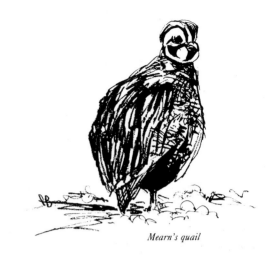

Mearn's quail

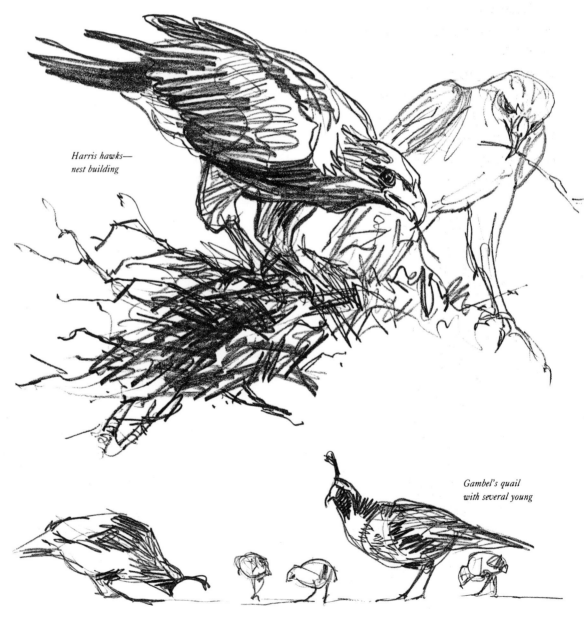

*Harris hawks—
nest building*

*Gambel's quail
with several young*

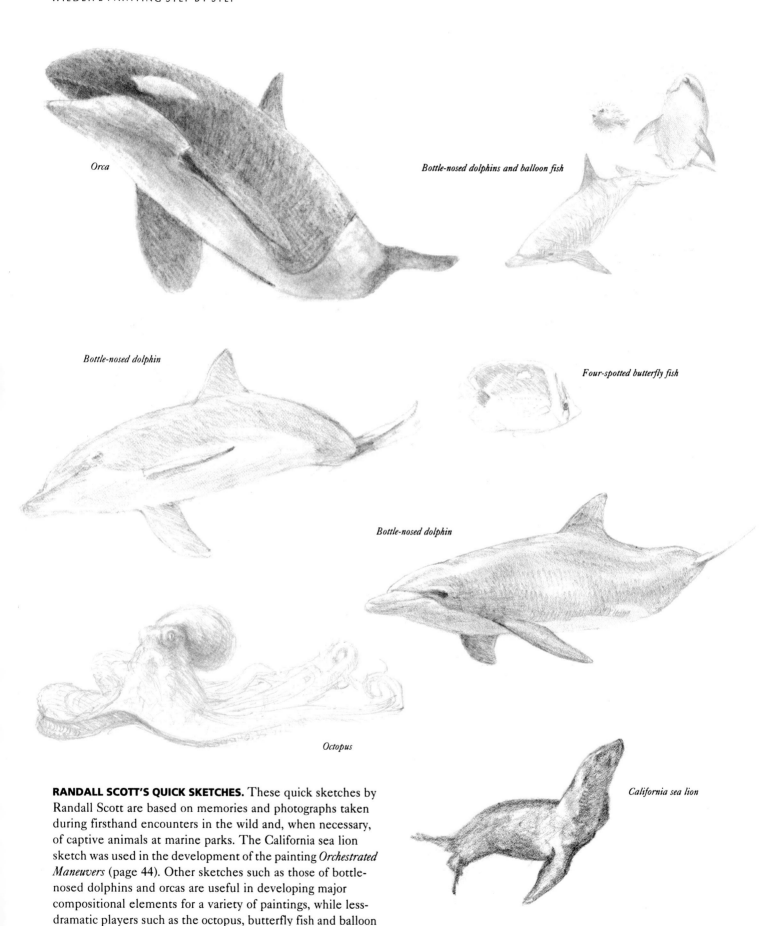

Orca

Bottle-nosed dolphins and balloon fish

Bottle-nosed dolphin

Four-spotted butterfly fish

Bottle-nosed dolphin

Octopus

California sea lion

RANDALL SCOTT'S QUICK SKETCHES. These quick sketches by Randall Scott are based on memories and photographs taken during firsthand encounters in the wild and, when necessary, of captive animals at marine parks. The California sea lion sketch was used in the development of the painting *Orchestrated Maneuvers* (page 44). Other sketches such as those of bottle-nosed dolphins and orcas are useful in developing major compositional elements for a variety of paintings, while less-dramatic players such as the octopus, butterfly fish and balloon fish are most likely to appear as background elements.

PHOTOGRAPHIC REFERENCE

SHOOTING YOUR OWN PHOTOGRAPHS

To shoot your own photo references, you'll need a good 35mm "through-the-lens" reflex camera and one or more telephoto lenses. Danny O'Driscoll, for example, carries two Pentax 35mm reflex cameras. On one he uses either a standard 50mm lens or a fixed 400mm telephoto; on the other he uses a zoom telephoto that can provide magnifications from 70-200mm. A camera with a motor drive is ideal for "stop-action" shots of wildlife in motion. For underwater wildlife subjects such as those painted by Mark Susinno and Randall Scott, you'll need a waterproof underwater camera. A less-expensive underwater camera will do for shallow water, but you'll need more expensive equipment, lights and specialized training if you anticipate shooting in deeper water.

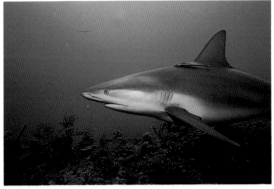

This shot of a reef shark is typical of those taken by Randall Scott while scuba diving in the Caribbean. After tying some barracuda to a coral head as bait, Scott waited about ten feet down-current and was soon rewarded with three female reef sharks ranging in size from five to eight feet long. Once they'd gulped down the bait, they circled the area, allowing him to get good close-up reference photographs.

Scott supplements his reference photos of sea life with close-ups of underwater "landscape" details such as this kelp leaning into the current off Catalina Island. A single painting often contains details based on elements from as many as fifty or sixty individual photographs.

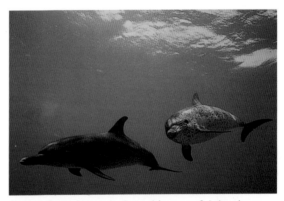

Scott takes photos such as this one of Atlantic spotted dolphins in the wild and at marine parks. This was taken during a dive trip to the Bahamas.

Scott took this photo to capture the details and colors of palm kelp and eelgrass in shallow water. The reflections on the underside of the water in this photo were used as reference for *Sand Shark* (page 107).

Although a clown fish would seldom be the main subject of a painting, photos such as this (taken in Fiji) provide valuable background details and "action" that allow Scott to create a more authentic environment.

SLIDES VS. PRINTS

Most wildlife artists prefer slides over prints because of their superior clarity and color. On the other hand, although photographic prints seldom reproduce color or capture light as well as slides, they require no special viewing equipment. Slides are compact and easy to file, but they are also more difficult to use while painting. Some wildlife artists cope with this limitation by using rear projection screens or small handheld viewers. Lesley Harrison shoots slides but has crisp 8″×10″ or 11″×14″ Cibachrome enlargements made of any she plans to use as reference for paintings.

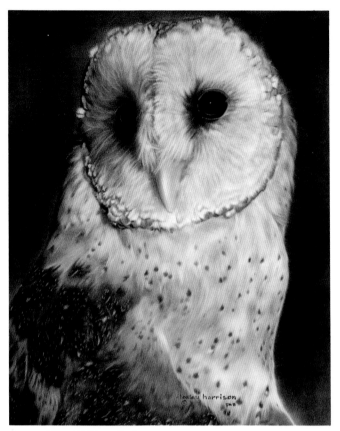

Barney, 14″×11″ (Barn Owl)
Original pastel by Lesley Harrison

Black swans (note how photo gives overdark shadows)

"Barney is a barn owl who lives in a wildlife rescue center near where I live," says Harrison. "His wings hadn't formed properly so he couldn't be released into the wild. Nevertheless, he often spent evenings roaming the floor visiting other wildlife guests in their cages. Unfortunately, since he couldn't fly, he couldn't get himself out of 'predicaments'—one night he strolled into the bathroom, got up on the toilet, fell in, and couldn't get out. Thereafter, the staff posted a sign on the door—'Please close the seat so Barney won't drown.'"

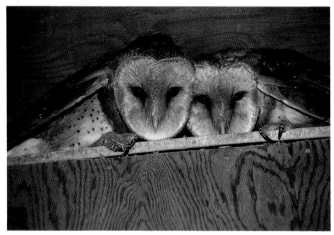

Barn owls

WORKING FROM SLIDES. Many wildlife artists prefer to work from slide images such as these because they give a more life-like feeling of light and more accurate color than photographic prints. Artist Paul Bosman views his reference slides through a small telescopelike handheld viewer with a focusable eyepiece. When holding the viewer to his eye, he says, the effect is almost like seeing the subject in the wild.

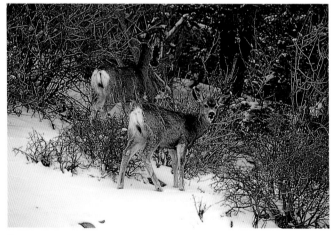

Deer

PHOTOS BY LESLEY HARRISON

CATALOGING REFERENCE MATERIALS

Regardless of which format you use (slides or prints), you'll need a system for cataloging your reference materials so you can locate desired references with a minimum of hassle. Artist D. "Rusty" Rust keeps thousands of photographic prints categorized according to subject in file cabinet drawers along with over 250,000 slides and transparencies in albums covering two walls of his studio. For Rust and other wildlife artists, these references contain not only wildlife but also a host of related details of landscapes, rocks, branches and streams that might prove useful in creating future compositions.

PURCHASING REFERENCE PHOTOS

Sometimes it simply isn't possible to get good photographic reference materials of your own. Perhaps you need to complete a painting on a tight deadline and have no appropriate reference in your files, or perhaps the wildlife in question is extremely elusive. Although most wildlife artists prefer to work from their own reference photographs, nearly all occasionally purchase reference from professional wildlife photographers. In the back of *Wildlife Art News* or *Outdoor Photographer* you will see ads offering professional slides or prints of wildlife for a fee (see "Wildlife Organizations and Publications"). Fees vary from five to fifty dollars or more per image. Photographers may sell "all reproduction rights" for this fee or more limited rights. Make certain you understand what reproduction rights you are purchasing and ask for a thorough explanation if you're unsure.

PHOTOS BY PAUL BOSMAN

LANDSCAPE HABITATS. A wildlife artist's reference library should contain not only slides of wildlife subjects but also details of landscape and habitat such as these reference photographs that Paul Bosman used as he developed his painting *Oak Creek Bandit* (page 87). Compare them to the finished image.

USING PUBLISHED IMAGES

Books, magazines and wildlife videos provide a veritable cornucopia of visual reference and descriptive text that no sane wildlife artist would be without. A sampling of these are listed in "Wildlife Organizations and Publications" at the end of this book. Keep in mind, however, that each of these published photographs is the copyrighted property of the photo-artist who took it. It is illegal to copy these images—even in another medium such as oil, acrylic or watercolor—without the owner's permission. You can, however, use published reference freely to verify details of anatomy, coat, coloration, and so on and to help you refine your own sketches of wildlife postures and movements.

HAZARDS OF USING PHOTOGRAPHIC REFERENCE

The most obvious drawback for the artist lies in copying photographs literally without regard to the basic principles of design and composition that differentiate art from photography. Beyond this are a host of other hazards that results when an artist fails to compensate for the difference between the way the human eye and a camera "see" the same subject such as overly dark, "dead" shadows and incorrect foreshortening. Furthermore, when elements from different photographic sources are brought together in the same image, additional dangers lurk in the form of incorrect perspective, conflicting light sources, and problems of scale between various elements in the composition. Fortunately, these problems can be overcome by firsthand observation, well-developed drawing skills, and an awareness of the hazards themselves.

A telephoto lens is essential for a shot like this of a black bear up a tree.

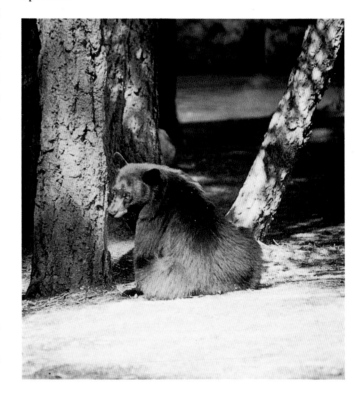

Zoo residents aren't the only animals that occasionally get overweight. This "portly" backcountry black bear from Kings Canyon National Park has supplemented his diet liberally with food stolen from hikers and backpackers.

OTHER SOURCES

ZOOS, REFUGES, WILDLIFE REHABILITATION CENTERS, AND PRIVATELY OWNED EXOTIC ANIMALS

In much the same manner that a camera streamlines field sketching, zoos, refuges and "rehab" centers simplify the time-consuming task of locating suitable subjects in the wild. Almost any desired wildlife species can be located in captivity, but like photographic reference, this availability comes at a price. "Zoo animals are very often overweight, possibly through lack of exercise," says Paul Bosman, "or underweight perhaps because of illness. Horns or antlers can appear vastly different from their counterparts in the wild as a result of constant rubbing against bars or cement, which may alter their color, texture or shape." Beyond this, captive animals may not exhibit the same habits, gestures and seasonal behaviors of those in the wild, and needless to say, their habitat is seldom of their choosing.

WILDLIFE BIOLOGISTS AND RESEARCHERS

Wildlife biologists and other researchers can be invaluable sources of information and may provide unique opportunities for observing wildlife in the field. "If you're lucky enough to befriend a wildlife biologist," says Paul Bosman, "you might be able to go on field trips for a head count or assist in gathering data on a particular species." For Bart Rulon, wildlife biologists are a source of expert advice. "If I'm in doubt about an animal or plant species or its habitat," he says, "I'll seek advice from wildlife biologists." Randall Scott expands the expert network still further by consulting fellow artists, divers, marine biologists and underwater photographers who, he says, are also eager to share insights and experiences that may help him in his paintings.

PRESERVED SPECIMENS

Preserved specimens can provide useful information when a live subject is not readily available, but they do have drawbacks. First, they may look nothing like the living animal. Second, it may be illegal to possess certain specimens without special permits. "In most states," says Danny O'Driscoll, "it's illegal to keep even a single feather from a nongame bird. In order to get firsthand knowledge of my subjects legally, I obtained a scientific research permit from my state wildlife department. With it, I can legally retrieve specimens that have been killed along the highway or in the wild." Randall Scott also acknowledges the occasional usefulness of keeping small specimen fish in a freezer, but like most wildlife artists, he prefers to work from living animals observed in their natural environment.

Sketch by Danny O'Driscoll

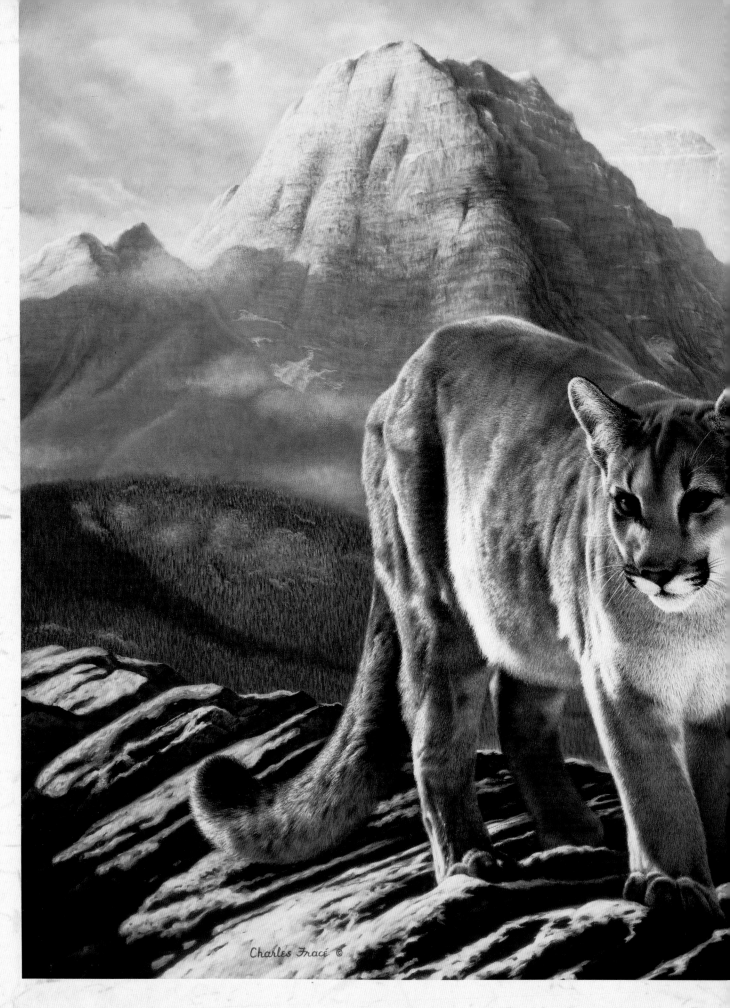

Charles Fracé ©

3

PAINTING REALISTIC HABITAT

Wildlife art is unique among the fine arts because the research for a painting often takes considerably longer than the act of painting itself. In fact, according to Danny O'Driscoll, "research is 75 percent of a painting." Most wildlife artists share this view. "When one has an intimate knowledge of the animal and its environment," says Paul Bosman, "then all else follows: getting the anatomy right, recognizing typical gestures, knowing when the animal will do what and why. It's knowing when a particular antelope has its rutting season and how the male's disposition changes—the way it stands and tests the air. It is knowing the habitat at that time of year and what the ratio of males to females is likely to be in a given area."

Cougar, 28″ × 34″
Oil, Charles Fracé

RESEARCHING HABITATS

Whenever possible, professional wildlife artists observe, sketch and paint their subjects in a natural setting. Occasionally, wildlife refuges or rehabilitation centers can provide a convenient source for reference on the animal and its habitat. This information can then be combined with firsthand observations.

In their work, some artists, like Paul Bosman, concentrate on wildlife species that can be observed and studied within a reasonable driving distance from home. Although born in South Africa and well known for his paintings of African wildlife, Paul Bosman now divides his time between those subjects and North American species, such as mountain lions, bighorn sheep, javelinas, Sonoran pronghorns, and desert-dwelling birds found near his home in Sedona, Arizona. His painting of desert bighorn sheep, *High Noon* (page 40), was completed only after spending a week observing and sketching the animal in its natural habitat in Organ Pipe Cactus National Monument.

Paul Bosman's sketches of desert bighorn sheep.

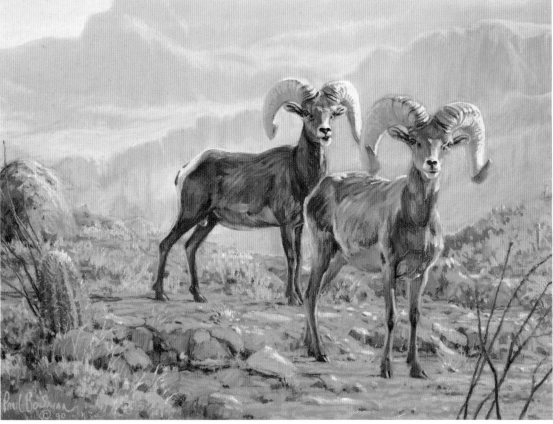

Desert Rangers, 14″ × 20″, Pastel, Paul Bosman

"These two magnificent rams just had to come together in one painting," says Bosman. "I used a slab of Arizona rock to provide tonal contrast and show off their beautiful headgear. I enjoyed the juxtaposed use of complementary color."

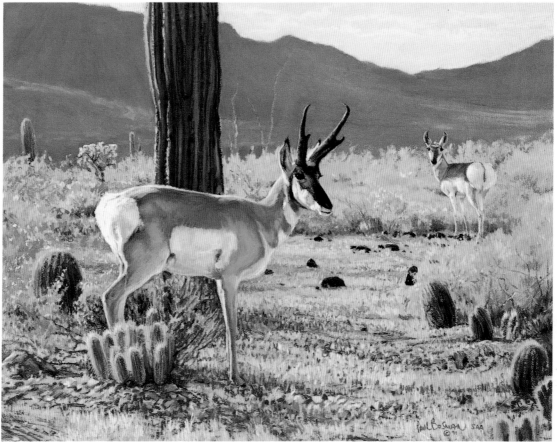

Phantoms of the Desert, 19½″ × 25½″ (Sonoran Desert Pronghorn)
Pastel, Paul Bosman

FIRST-HAND OBSERVATION. "Cabeza Prieta National Wildlife
Refuge in Arizona has been given the lead responsibility for
the recovery of these endangered animals," says Bosman. "I
was invited to visit the refuge and observe and paint the ante-
lope in their natural habitat. I used the local vegetation and
coloring to place the scene in the southwest."

Paul Bosman's
sketches of Sono-
ran pronghorns.

TAKE AN ANIMAL ON LOCATION

"Miss Montana belongs to a friend of mine," says Lesley Harrison. "To get the reference for this painting, we drove to an area of snow-covered ranch land—me, my friend and the mountain lion all in the same car. When we arrived, my friend turned the mountain lion loose. I would stalk her with my camera and then she'd stalk me and jump on me, knocking me down. Although she had been declawed and was a sweetheart who'd purr when you petted her, she still had her teeth. I didn't have the sense to be scared at the time, but since then, I've seen some bad accidents happen to people who forgot that these animals are always wild in their hearts."

Harrison has cultivated relationships with zoo curators, owners of exotic pets, and staff members at wildlife rehabilitation centers. "Over the years," says Harrison, "I've found that people are unbelievably cooperative. I've gotten to know a lot of curators and public relations people, and usually all it takes is a call to arrange to photograph the animals in their cages or on a leash."

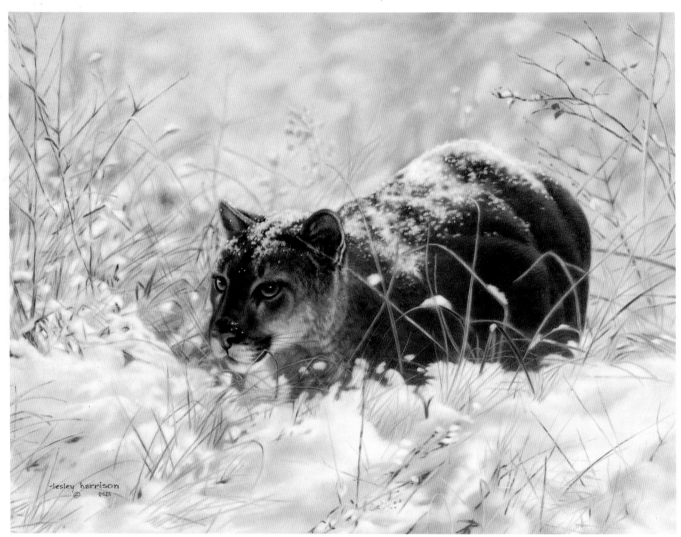

Miss Montana, 18" × 24" (Mountain Lion)
Pastel, Lesley Harrison

BRING THE ANIMAL TO THE HABITAT. If you're able to work with wild animal handlers, try taking an animal "on location"— to an area resembling its natural habitat.

"BUILDING" A HABITAT

For Randall Scott, observing his subject's natural habitat is an essential part of the painting process. The nature of that underwater habitat, however, makes it necessary for him to reconstruct it in his studio from memory images, photographs, guidebooks, and even occasional mock-ups, such as the diorama shown at right.

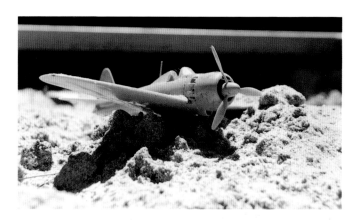

Randall Scott's sandbox reef diorama.

Zero Tolerance, 30″ × 48″ (Silver-tipped Sharks)
Acrylic, Randall Scott

CREATE A HABITAT. "Most of the time when you dive a wreck," says Scott, "it's unrecognizable—just a pile of rubble on the bottom. So, to create this scene, I bought a model plane and set up a little reef diorama in a sandbox. For the painting, I added my own incrustations. The reef was based on reference from the central Pacific; the sharks were based on reference of silver-tipped sharks common in the south Pacific."

USING PHOTO ARCHIVES

D. "Rusty" Rust frequently combines reference material from his vast photo archives to create stronger compositions that tell more of a story. "Most often," he says, "when creating a painting, I try to have something of interest other than the main subject. In *Red Fox* (below), for example, the ferns and butterfly were the main subject. Adding the cute, impressive fox gave viewers a focal point." To create *Red Fox*, Rust made a landscape from separate slide references for the fox and butterfly and then created the ferns from other research materials.

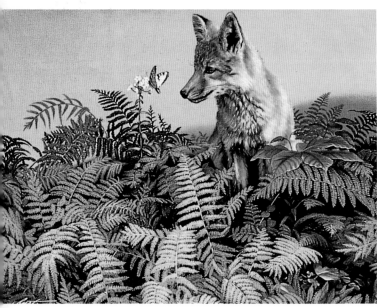

Red Fox, 30″ × 40″
Oil, D. "Rusty" Rust

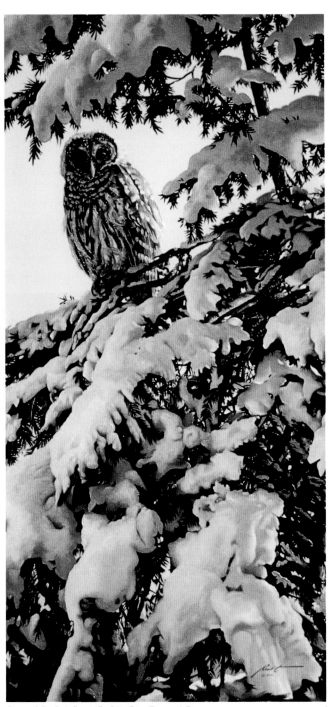

Barred Owl, 48″ × 24″, Oil, D. "Rusty" Rust

COMPOSED FROM TWO SLIDES. "This painting is a composite of material from two slides—one of the owl and the other of the tree. I was impressed with the snow on the pine branches and the way the sunlight came through the tree. The scene just needed some life, so the owl fit in quite well."

GENERALIZED HABITATS

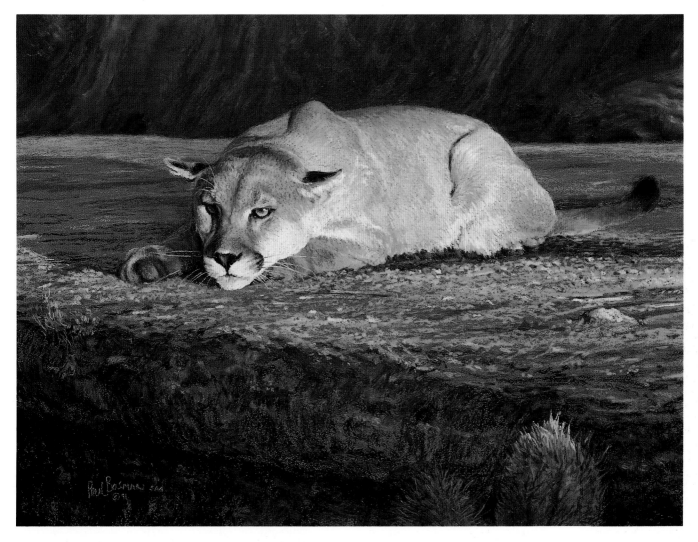

Five O'Clock Shadow, 20″ × 26″ (Desert Mountain Lion)
Pastel, Paul Bosman

Occasionally, you may want to place an animal in a generalized habitat. A generalized habitat should be correct in its essentials but needn't be as detailed or as literal as in most wildlife paintings. Generalized habitats are a useful device in four key situations affecting color, design, mood and background:

USING "ARTISTIC LICENSE" WITH COLOR

As Mark Susinno points out in the next chapter, slavish devotion to reality often leads to boring paintings. Many skilled wildlife artists concur. "Color," says Paul Bosman, "is as important as anything else. Choosing the right colors can set the mood—from cool, delicate softness through vibrant and dynamic warm colors with judicious use of complementaries to add visual interest."

ENHANCE THE COLOR OF SUNLIGHT. In this painting, Bosman was interested in focusing attention on the mountain lion and creating a feeling by the dramatic use of color. To accomplish this, he generalized the habitat, selecting landscape elements that were typical of the mountain lion's usual surroundings.

"I was able to observe this large male mountain lion in its natural habitat," says Bosman, "while accompanying researchers in the vicinity of the Harquahala Mountains in western Arizona. I tried to create visual excitement by using sunlight on the subject and by the choice of pose. The thought that the 'sun may be setting' on this species crossed my mind and was something I considered for a title."

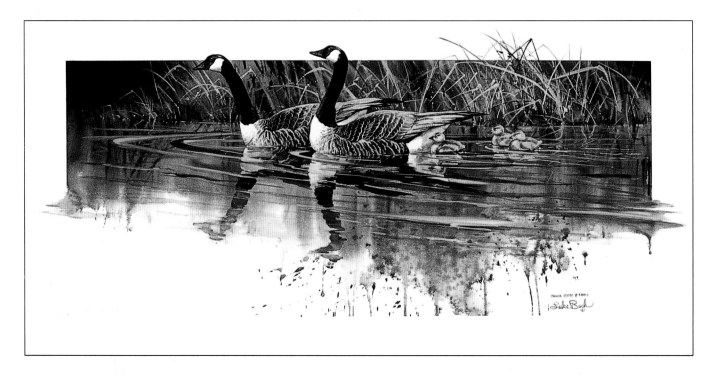

Canada Geese and Family, 20″ × 40″, Watercolor, Luke Buck

UNIFYING A GROUP. "I wanted to depict a family unit," says Buck, "since these geese mate for life. To make them stand out, I kept the background dark and simple to frame them."

USING "ARTISTIC LICENSE" WITH DESIGN

As many wildlife artists acknowledge, wildlife art should be judged by the same standards of composition and design as are all other forms of fine art. Naturally, not everyone agrees on the balance between literal accuracy and artistic considerations. In the end, those are precisely the sort of intimately personal decisions that define an artist's style. For Luke Buck, this means that "as a wildlife painter, I'm an artist first. I try for fairly accurate renderings of my subject in an artistic manner, with close attention to design, color, balance—all the standards we apply to all other types of art." (Buck's painting techniques are described in detail in the demonstration section at the end of this book.)

Regal, 20″ × 15″ (Florida Bobcat)
Watercolor, Luke Buck

REVEALING CHARACTER. "At a Florida wildlife rescue center this bobcat always ate first, being the most aggressive. To capture his regal air I chose a dark background to frame him."

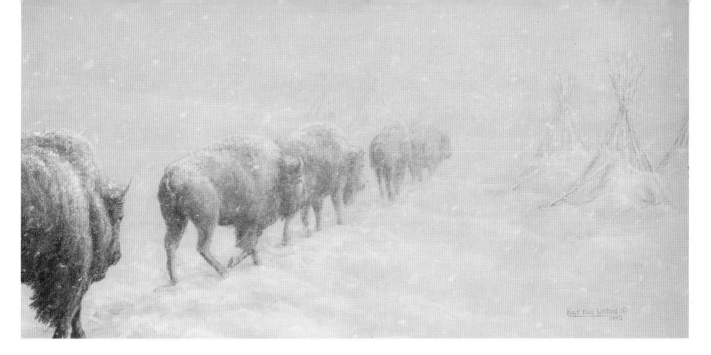

USING AN INDEFINITE HABITAT TO CREATE A MOOD

Many wildlife artists use fog, early morning mists or snow to subordinate details of an animal's habitat. These obscuring devices can be useful for setting a mood of quiet or isolation. An indefinite background can also be used as a kind of "shorthand" for details of habitats that can't be readily observed, as Karl Eric Leitzel has done in *Looking Back* and *Remnants—American Buffalo*.

USING A SOFT-FOCUS BACKGROUND TO HIGHLIGHT THE SUBJECT

Contrasting a sharply detailed and physically accurate foreground against a soft-focus background is a time-honored device for highlighting a wildlife subject. The demonstration by Danny O'Driscoll on the following pages describes how to apply this useful device in your own paintings.

Looking Back, 16″×12″, Acrylic, Karl Eric Leitzel
Collection of William and Marilynne Stout

Leitzel combined reference photographs and sketches of elk obtained at a nearby wildlife sanctuary with sketches of a typical ridgetop from the Pennsylvania mountains. The atmosphere created by the falling snow focuses attention on the elk and emphasizes the tension created by the knowledge that in a moment, the elk will turn and quickly vanish into the swirling snow.

Remnants—American Buffalo, 12″×24″, Acrylic, Karl Eric Leitzel
Collection of Dr. and Mrs. Thomas E. Klena

A MOODY MEMORIAL. Here, Leitzel used the atmosphere of falling snow to evoke a mood. "When I began working with this idea," he says, "I felt something was missing. Reality and art merged when I realized that the missing element was the traditional Plains Indian. Combining the tattered remains of a summer encampment with the disappearing herd became my way of memorializing their shared fate."

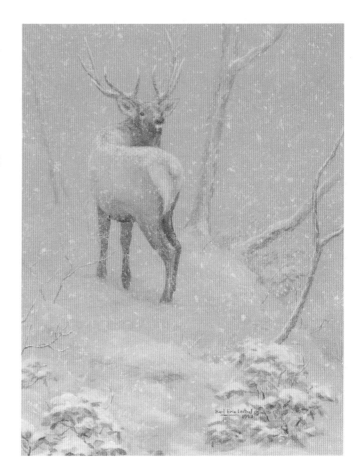

Demonstration

CREATING SOFT-FOCUS BACKGROUNDS WITH AN AIRBRUSH

DANNY O'DRISCOLL

Soft-focus backgrounds are an easy and effective way to create a believable sense of depth in wildlife paintings. They're comparatively easy to paint in oils or watercolors but almost impossible in acrylic because acrylic colors simply do not blend well. Wildlife artists have developed many innovative ways to cope with this often troublesome downside of acrylic. When it comes to soft-focus backgrounds, however, nothing tops the ease of an airbrush.

Artist Danny O'Driscoll creates stunning soft-focus backgrounds on gessoed hardboard panels using a "double-acting" Paasche VL model airbrush. Before he paints, he thins several standard acrylic tube colors with water (Ivory Black, Ultramarine Blue, Hooker's Green, Cadmium Yellow Pale, Azo Yellow-Orange, Burnt Sienna and Burnt or Raw Umber). Then he pours the thinned paint into empty plastic 35mm film containers.

For efficiency and convenience, O'Driscoll completes backgrounds for a number of paintings on several panels at each session. Leftover colors can be stored in the 35mm plastic film containers for several days between sessions.

1 **AIRBRUSHING THE BACKGROUND.** To paint the background for *Happy Hummers*, O'Driscoll poured a small amount of thinned ivory black into the color cup of his airbrush and set the pressure at 40 psi. By varying the air and paint flow using the airbrush's double-acting "trigger," he was able to produce a range of values from pale grays to deep darks. These variations suggest light reflecting off surfaces in the distance as well as the dark, shadowy forms of trees.

When finished with black, he cleaned the airbrush's color cup and internal mechanism in the five-gallon bucket of water that is always at his side. Next, he loaded the color cup with Ultramarine Blue to build cool shadows and a suggestion of sky at the top of his panel. He followed this with passages of Hooker's Green and then with a red-orange or yellow mixture for sunstruck areas. When these basic colors were down, O'Driscoll returned with either Burnt or Raw Umber to unite the previous colors and give the background a natural color balance.

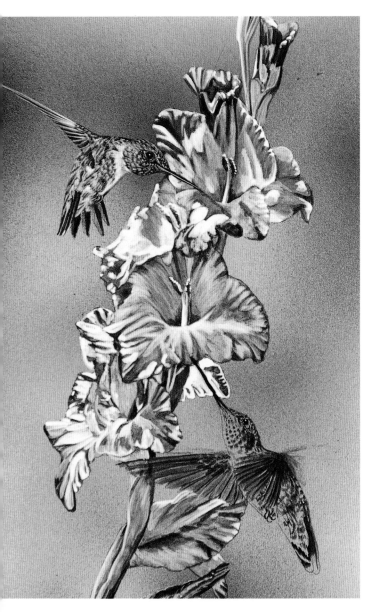

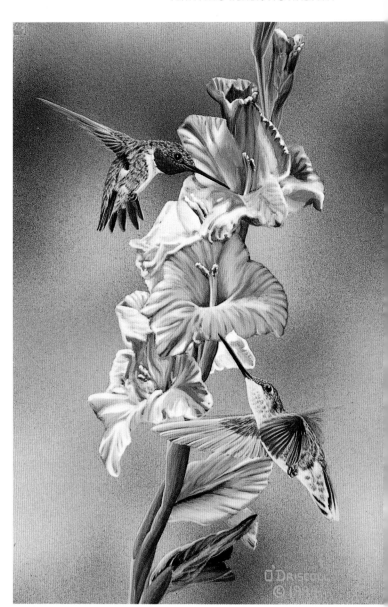

2 BLOCKING-IN HUMMINGBIRDS AND FLOWERS. When the background had dried, O'Driscoll sketched his subject directly onto the panel and completed the remainder of the painting using conventional brushes. Following the same general color sequence as in the background, O'Driscoll used thinned Ivory Black to establish the forms of the blossoms, stem and the hummingbirds (with their wings slightly blurred to suggest motion). Next, using Titanium White, he strengthened the sunlit sides of each of those elements to complete the basic value structure for the painting.

3 COMPLETED PAINTING. Next, O'Driscoll selectively glazed each of the foreground elements with Ultramarine Blue, Hooker's Green, Hansa Yellow Medium and a series of reds, violets and oranges to establish the appropriate balance of local color. To complete *Happy Hummers*, he drybrushed passages where necessary to create believable textures and then added the highest highlights using straight-from-the-tube colors with very little water added.

Happy Hummers, 11″ × 8½″
Acrylic, Danny O'Driscoll

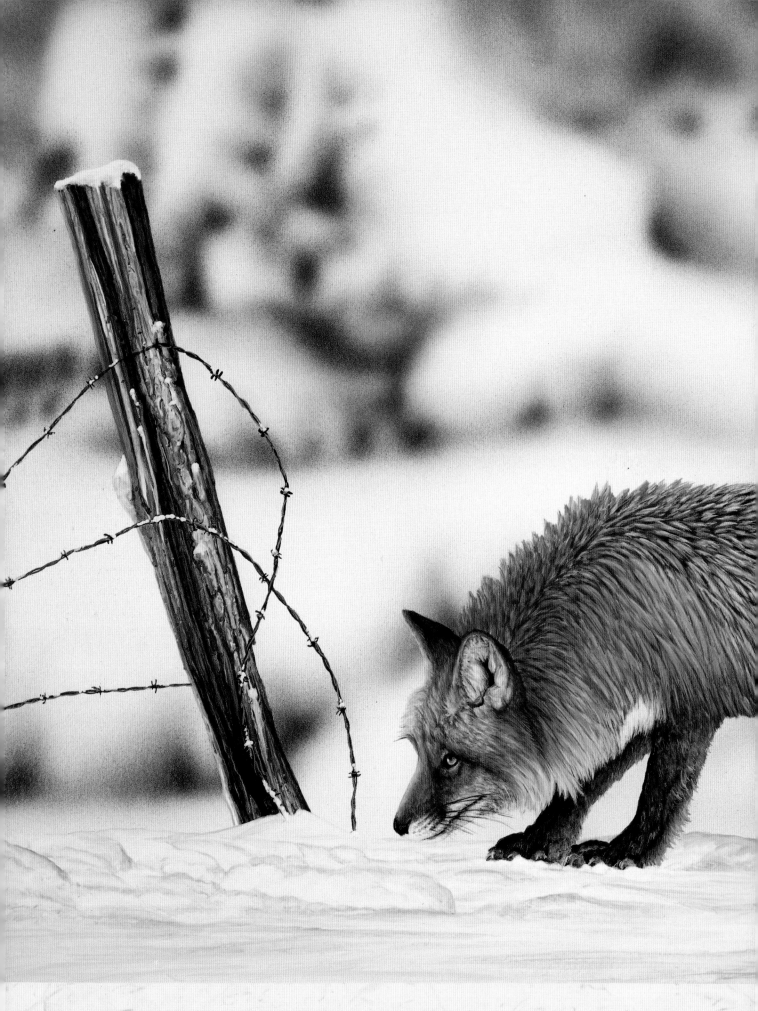

4

POSING AND COMPOSING

One theme constantly repeated by the artists whose work appears in this book is this: Wildlife art must embody the same standards of composition and design as other works of fine art. At the same time, accuracy is equally important because the physical details of wildlife subjects are well known, exacting and valued by collectors. Therefore, the need to balance art with accuracy is one of the more important challenges facing contemporary wildlife artists. "The danger," says Mark Susinno, "in relying too heavily upon the authenticity of one's reference material is not so much that it can lead to bad paintings, as that it too often leads to boring paintings."

On the Trail, 17½″ × 24½″
Acrylic, Danny O'Driscoll

COMPOSING YOUR PAINTING

The objective of composition and design is to avoid boring paintings by creating a coherent arrangement of visually stimulating shapes and values. If you're unsure about composition and design, there are many excellent books and courses on the subject. Keep in mind, however, that while the principles of good composition and design are well known, their application remains largely intuitive. Here are two basic principles that may help you judge the soundness of your composition and overall design.

A JIGSAW PUZZLE

First, ignore all the depth cues in your image and look at each of the elements as abstract pieces of a jigsaw puzzle—a simple two-dimensional arrangement of interlocking shapes and values. Are the colors, values, shapes and their relationships pleasing on their own, regardless of the subject? If you're unaccustomed to evaluating your work in this way, try looking at your painting upside down or reversed in a mirror. To get a better idea of how this works, take a look at David Rankin's *Morning in Bharatpur* and *Beach Bullies* (pages 48 and 49). In each image, the abstract design is readily apparent and is as pleasing as the subject itself.

AN ILLUSION OF SPACE

Second, examine your image as a three-dimensional illusion. Are your depth cues convincing and consistent? Do colors become cooler in the distance? Do edges become less defined as they recede into space? Do objects overlap? Is your perspective correct, and are the sizes of the wildlife and other elements in proper relation to each other? Is your lighting consistent?

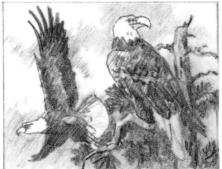

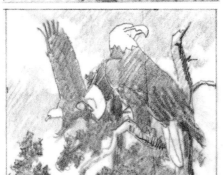

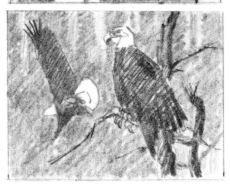

Compositional sketches by Don Enright.

YOUR OWN APPROACH

In the end, composition remains a largely personal and intuitive process. Some artists plan their compositions in great detail using thumbnail sketches while others work from a generalized mental concept that they develop intuitively as the image progresses. Other artists use a hybrid method; they establish the background or landscape elements of the scene with a general idea of where the subjects will be placed but decide on final placement or exact postures only after they've moved a tracing or cutout of the subject over the background to see what "feels" right.

In general, the unforgiving nature of watercolor and pastel makes it more likely that artists working in these mediums will plan compositions in considerable detail before painting. Artists working in oil or acrylic can make sweeping changes well into the painting process. Your own approach to composition must reflect not only the classic principles of design and composition but also your temperament, the limitations of your medium, and the demands of your subject.

TEN COMPOSITION IDEAS

1. CONVERGING DIAGONALS

Paul Bosman says, "I'd seen Alaskan black bears many times in the wild and in captivity, but when I saw these cubs at a local refuge, I knew it was time to start a painting. After experimenting with several variations in small thumbnail sketches (above right), I settled on a composition of converging diagonals that provided a strong base and accentuated the focal point (above left)."

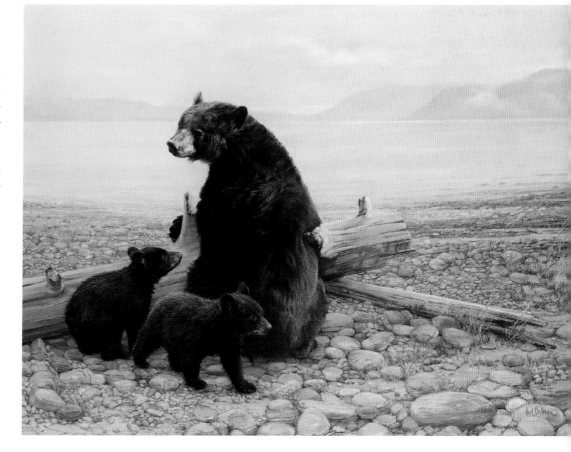

Shore Leave, 24″ × 36″
(Alaskan Black Bears)
Pastel, Paul Bosman

2. INTERLOCKING RECTANGLES AND TRIANGLES

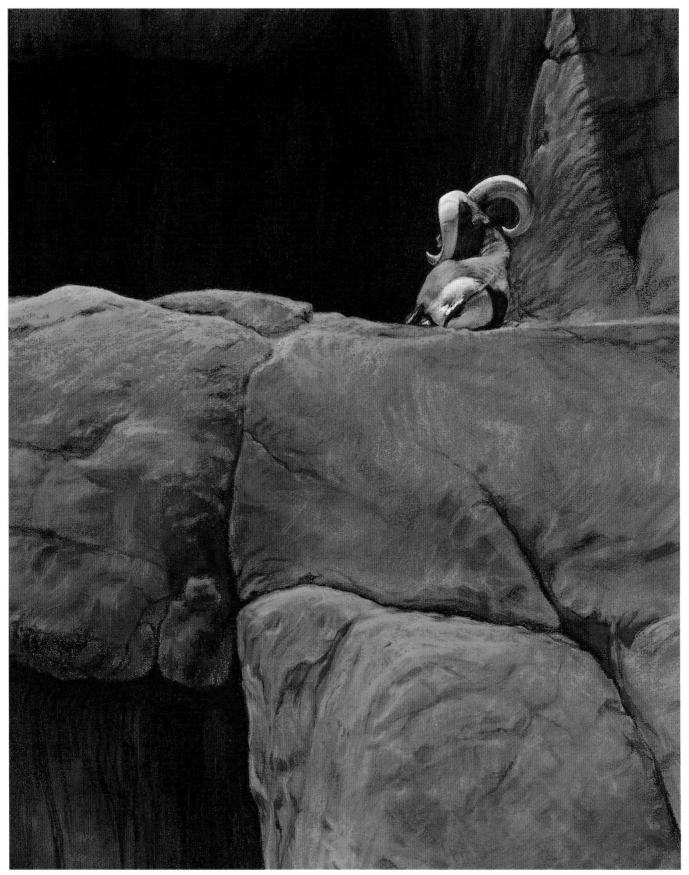

High Noon, 26″ × 20″ (Desert Bighorn Sheep), Pastel, Paul Bosman

"These lean rock climbers are impressive and so was their habitat," says Bosman. "I spent a week in Organ Pipe Cactus National Monument in southwest Arizona to get good reference material. After selecting a pose that would provide two distinctly different views of those superb horns, I finally decided to use only rocks as the setting in a Mondrian-style composition of interlocking rectangles and triangles with the bighorn sheep as the focal point."

3. A Z-SHAPED COMPOSITION

Something in the Air, 22″ × 30″ (Deer), Watercolor, Bart Rulon
Collection of Mr. and Mrs. Woodford Portwood

Bart Rulon explains, "In this painting, the landscape was as important as the subject. I wanted viewers to be intrigued with the snow scene and only afterwards see the deer. To accomplish this, I used a **Z** or zigzag pattern of shadows to take viewers back through the vertical trees. The large area of shadow behind the two trees on the left catches your eye first and then the diagonal shadows in the middle ground lead you to the deer in the upper right. If I'd wanted the deer to be noticed first, I would have placed them near the big shadow in the left front. I didn't because I felt that would remove the incentive to see the rest of the painting and because I wanted to portray them the way they're normally seen—at a distance."

4. A U-SHAPED COMPOSITION

Great Horned Owl, 24″×24″, Acrylic, Bart Rulon
Collection of Barbara S. Koessler

"Paintings of an owl in a tree are very common," says Rulon, "but I felt that the unique shape of the tree coupled with the lighting and shadow effects would constitute an idea that was different enough to pursue. The moment I saw this tree, I knew I wanted to place the owl in the bottom of the cradle and I knew the owl would prefer to be on the shaded side rather than on the sun-drenched side. Placing the owl in the U-shape formed by the tree trunk funnels your attention immediately to the owl; my hope is that, afterwards, viewers will follow the semicircle back down to investigate the interesting bark patterns and lighting effects on the tree."

5. AN X-SHAPED COMPOSITION

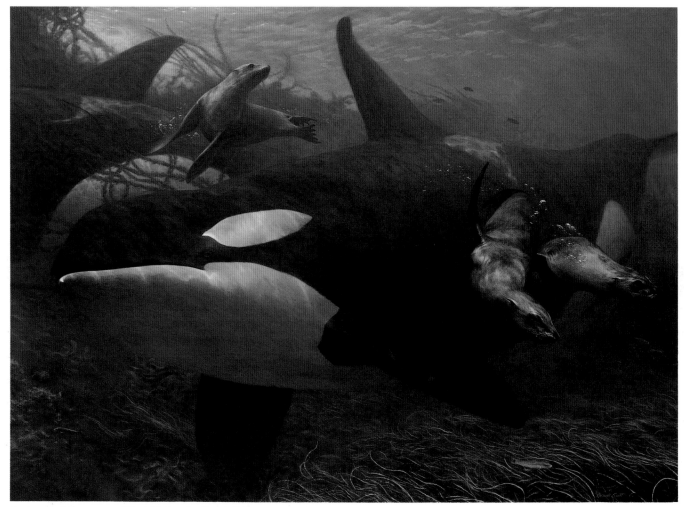

Orchestrated Maneuvers, 26" × 36", Acrylic, Randall Scott

Randall Scott says, "The interaction between predator and prey is one of the most challenging subjects because scenes such as this are unphotographable. So, using reference from a number of sources, I put predator and prey together in a believable situation and balanced the light at the same time. The killer whale was from a marine park in San Diego and I photographed the sea lions on a dive to the Coronado Islands.

"Orcas move a tremendous amount of water and I wanted to show their power. I used the bubbles coming off the sea lions and the sweep of the eelgrass to show the surge and current. The larger X formed by the criss-crossing shapes of the main elements is balanced by smaller xs formed by the sea lions."

6. THE SUBJECT AS DESIGN ELEMENT

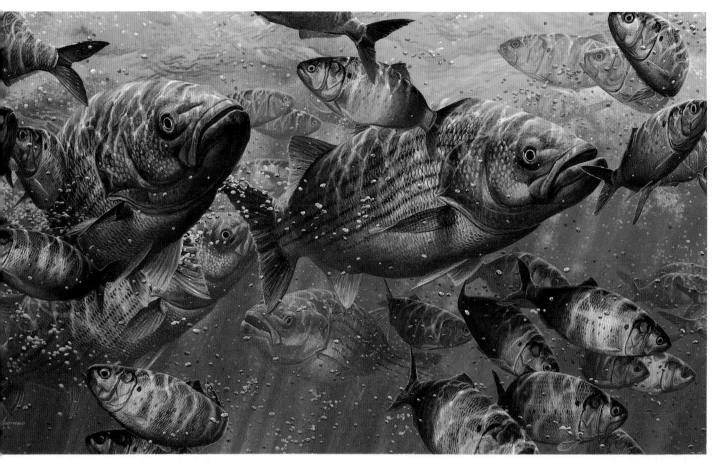

Pandemonium—Striped Bass, 20″ × 36″
Acrylic, Mark Susinno

Mark Susinno explains, "Often I use logs, rocks and vegetation as design elements to help me create an environment in which to place the fish that are the subjects of my paintings. In this case, I wanted to depict a scene of striped bass attacking a school of menhaden in which I used only the fish, the surface of the water from below, bubbles caused by waves, and fish breaking the surface as they attack the baitfish. I felt it was important to give viewers the sense of observing the action from within the school, so I cropped many of the menhaden near the painting's edge to give the impression that the action continued outside the scope of the image."

7. CONVEYING DEPTH WITH MUTED COLORS

*One More Loo*k, 10″ × 14″, Watercolor, Don Enright

Sketch

"This painting was inspired by that one last look you often get just before a buck disappears over the hill," says Don Enright. "To focus attention on the buck and build depth in the scene, I worked out the basic values and edges in a thumbnail sketch (at left), which I was able to use as a guide to complete the full-sized painting in color." Note how colors gradually become more muted as objects recede into the illusory depth of the painting.

TIPS FROM THE PROS

"A good painting should capture the character and personality of the subject. It should be a visual thesis on its subject, illustrating the habitat and look that makes that species uniquely individual."

—*Danny O'Driscoll*

8. INTERLOCKING VERTICALS AND HORIZONTALS

Two of a Kind, 10″×14″, Watercolor, Don Enright

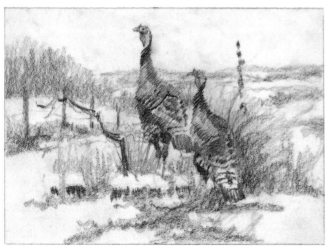

Sketch

Enright says, "Wild turkeys are normally extremely vigilant of any threats in their surroundings, but this pair seemed momentarily at peace. To convey that quiet mood, I balanced the verticals formed by their bodies and the fence posts against the quiet horizontals formed by the winter landscape."

9. BUILDING A VISUAL PATTERN

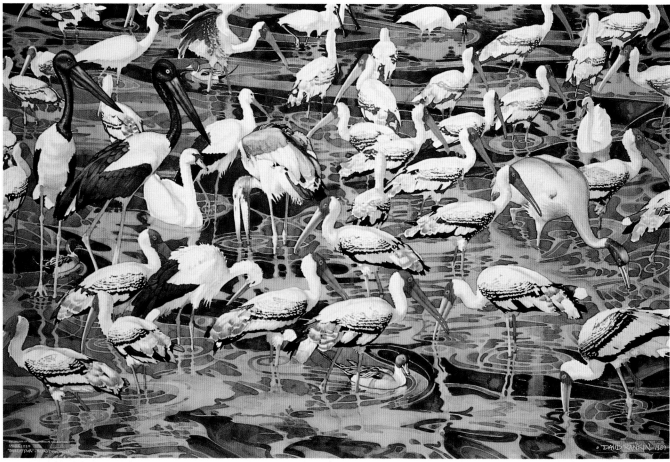

Morning in Bharatpur, 38″ × 58″, Watercolor, David Rankin

"People love to study birds up close," says David Rankin, "and Bharatpur in North India is by far the best place in the world to do just that. With images such as this, I'm striving to capture some of the presence I feel when I'm in the field in India. *Morning in Bharatpur* is a prime example of what I call 'natural abstraction.' The overall design of the birds creates a visual pattern that is very abstract even though the image is, in fact, realistic."

TIPS FROM THE PROS

"One of my most important tests for a painting concept is to ask if I've ever seen a painting in the past that looks like it. If so, I'll be less likely to pursue that idea because I want viewers to look at my painting and feel like they are seeing it for the first time."

—*Bart Rulon*

10. USING BOLD SHAPES

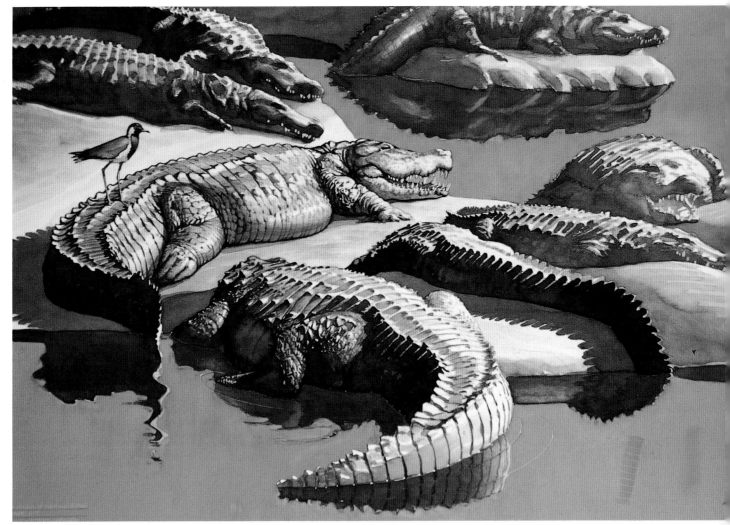

Beach Bullies, 28″ × 38″
Watercolor and gouache, David Rankin

Here, the bold shapes of the water and crocodiles can be appreciated as a pleasing abstract design long before the subject is identified. "The abstract design elements of a painting are like the girder substructure of a skyscraper," says Rankin. "You don't see them, but they're what actually holds the building up. For me, design elements are all-important. A poorly executed painting with a great design will attract more attention and acclaim than a beautifully painted work of art with a poor design."

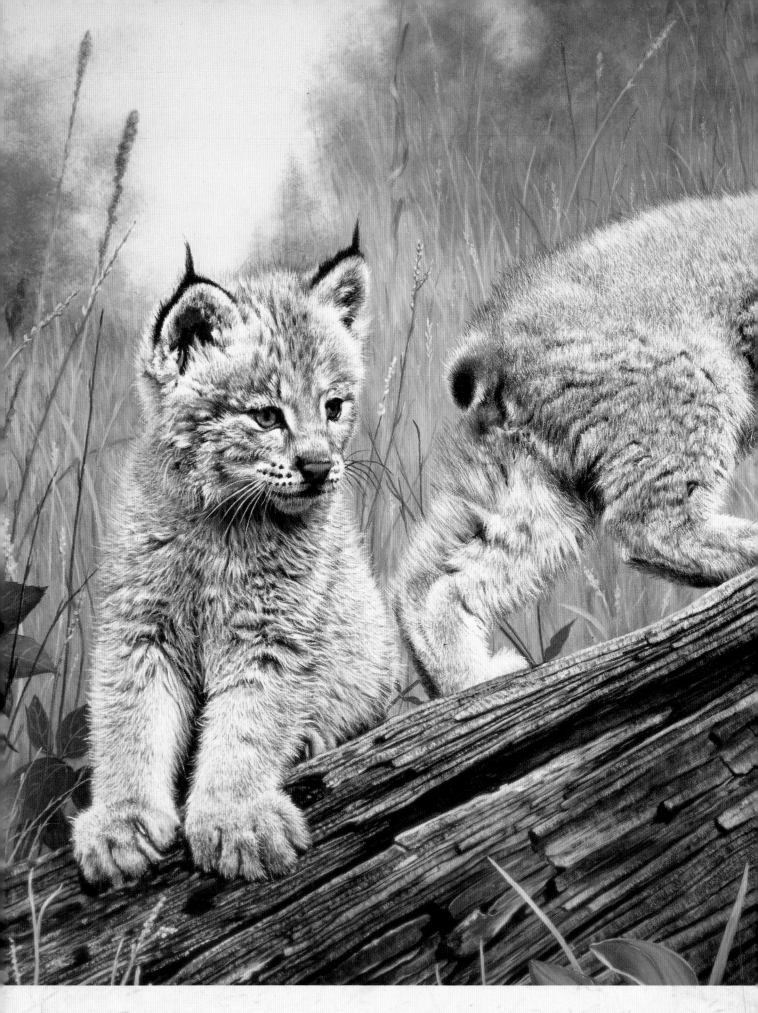

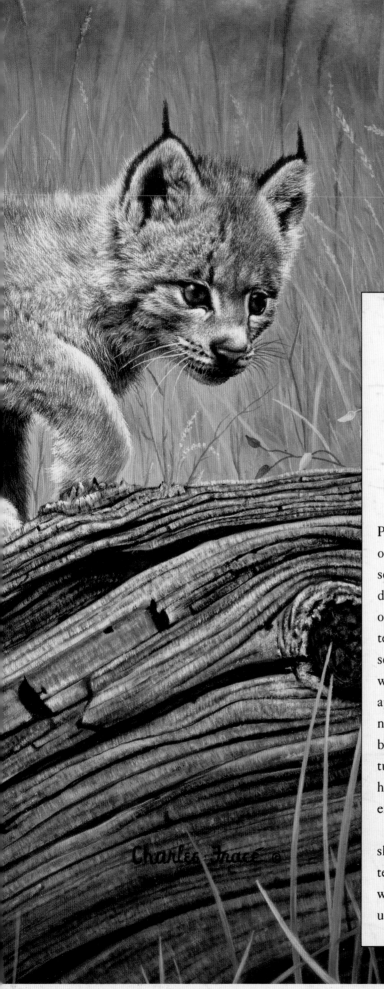

5

TECHNIQUES FOR PAINTING TEXTURES

Painting credible images of wildlife requires a panoply of interrelated skills. These include keen powers of observation, basic photographic skills, and the ability to draw and create artistic compositions. The culmination of all these skills is the ability to render the forms and textures of the wildlife subjects you've so carefully observed, sketched, photographed and composed. The wonderful diversity of wildlife species and their varied appearances makes it impossible to cover here any great number of these textures in detail. Fortunately, certain broad classes of textures are shared by many living creatures—birds have wings and feathers, most mammals have fur or hair, and many fish have scales and may exhibit some form of iridescence.

On the following pages you'll see demonstrations showing how professional wildlife artists render these textures (fur, feathers, scales and iridescence). Armed with their examples, you should be able to adapt these useful techniques to your own subject and medium.

Double Trouble, 19″ × 26″, Oil, Charles Fracé

PAINTING THE TEXTURE OF FUR

When you're painting wildlife it's relatively easy to capture readily observable anatomical features that differentiate one animal species from another. To paint truly credible images, however, you must also understand and be able to paint a host of more subtle features, such as an animal's coat—not only what it looks like, but how (or even if) its color and texture change with season or habitat.

An animal's coat is composed of either hair or fur, but when it comes to rendering the resulting textures, such distinctions may not be especially significant. Regardless of the term you use, as the paintings in this chapter clearly illustrate, fur textures and colors vary widely between different species.

Even so, you can use certain basic techniques to produce a realistic likeness of fur or hair. On the following pages are three step-by-step demonstrations by Persis Weirs that will show you how to paint several distinctly different types of fur.

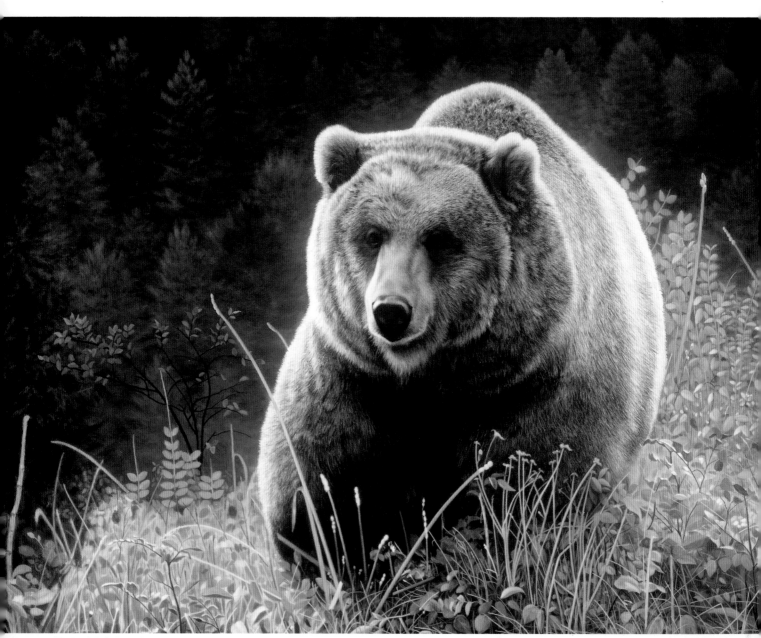

Unrivaled, 38″ × 50″ (Grizzly Bear), Oil on canvas, Charles Fracé

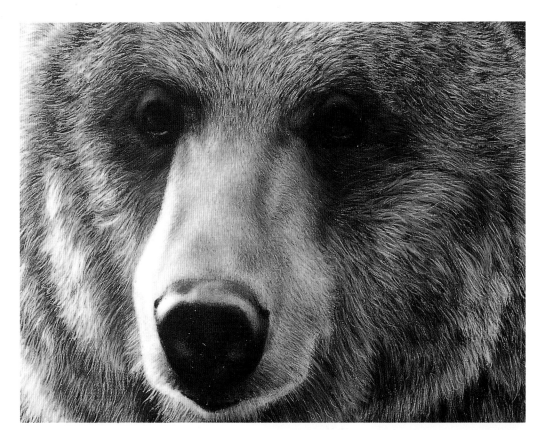

DETAILS OF CHARLES FRACÉ'S *UNRIVALED*
''Grizzly fur is dense and coarse compared to the softer fur of smaller mammals.''

THE TWO TEXTURES OF WOLF FUR

According to Persis Weirs, wolves have two basic types of hair in their coat: a fine, soft *undercoat* made up of dense, shorter hair that is generally lighter and relatively uniform in color; and an outer layer of *guard hairs* that are longer, coarser and more colorful than the undercoat. The undercoat's primary purpose is to provide winter insulation in the subzero habitat of the gray wolf. Most of the undercoat is shed when warmer spring weather returns, leaving the wolf with a much thinner coat and a leaner appearance in summer. The undercoat grows back in the fall. The outer coat (made up of guard hairs that typically grade in color from white at their base to black or brown at their tips) is more permanent, tougher, and more resistant to weather, wear and dirt. Thus, Weirs says, a wolf's overall color pattern is determined by its guard hair.

Area included in wolf fur demonstration.

1 "Although wolves' coats come in all shades of gray from black to white," says Weirs, "I've illustrated how to paint the area near where the wolf's neck and shoulder meet because the hair there shows the most variation in direction, length, texture and color shading."

Weirs first underpainted with a mixture of Raw Umber and Ultramarine Blue, using strokes consistent with the length and direction of the hair. She then worked outward from dark to light before adding shadowing in the lighter undercoat to give depth to the fur.

2 Next, Weirs thickened the hair with white and Raw Sienna, overlapping her strokes to develop the appearance of dense fur. To texture the fur, she "double loaded" a no. 0 round brush with white and Mars Yellow on the left side and Raw Sienna and Raw Umber on the right, adding more white to the combination as she worked toward the lighter chest area. In lighter areas, she enhanced the texture by using Raw Umber to separate the fur and "sink" the fur in some areas with graded shadows.

3 Weirs made certain that the guard hairs were longer and rather grizzled looking where the neck joins the shoulder. Below this, she made the fur on the shoulder shorter and somewhat tufted in appearance. She then refined colors further so the coat transitioned smoothly into a creamy white at the chest.

Finally, Weirs heightened the shaggy look of the wolf's coat by adding black tips to some of the guard hairs near the top of the shoulder and by lifting individual hair tips by highlighting them with white (followed with a light glaze of Raw Sienna to moderate the otherwise rather dead white).

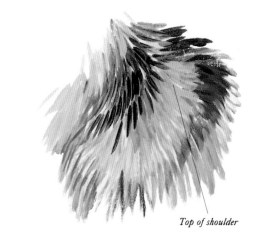

Top of shoulder

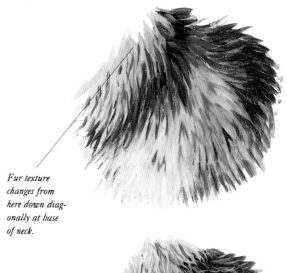

Fur texture changes from here down diagonally at base of neck.

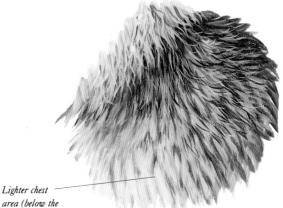

Lighter chest area (below the point of the shoulder).

Moon Shadows, 24″ × 36″ (Gray Wolves)
Acrylic, Persis Clayton Weirs
Courtesy of the artist and Wild Wings, Inc.

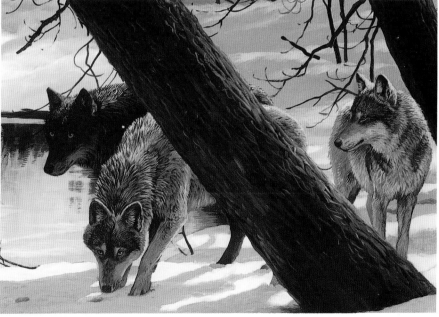

DETAIL

FROZEN FUR. In this painting, Weirs depicts how ice and snow cause the outer guard hairs of a wolf to freeze together into thick, separated spikes.

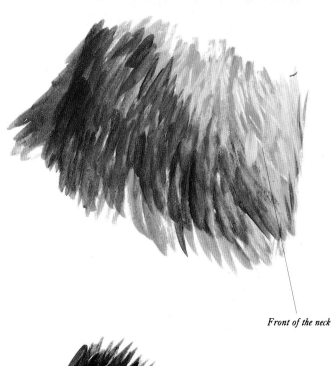

RENDERING WET FUR ON AQUATIC MAMMALS

The soft, dense fur of aquatic mammals such as otters, minks and beavers takes on an entirely different appearance once the animal enters the water and its fur becomes wet. As an example, Weirs notes, "It's interesting that on an otter's neck and chest the undercoat, when dry, appears rather dark in relation to the outer fur, but when the outer coat gets wet, the undercoat revealed between the wetted 'spikes' of outer fur suddenly appears much lighter."

Front of the neck

Location of wet otter fur demonstration

1 Weirs began by underpainting the area in a soft neutral brown using a mixture of Raw Umber/Burnt Umber and white, lightening the color as she approached the front of the neck. Using a no. 0 round brush, she carefully placed each stroke to follow the length and direction of the fur.

2 Next, in the darker area, Weirs used a mixture of black and Burnt Umber to separate the fur into spikes that form when wet guard hairs cling together. For the lighter area, she used a mixture of Raw Umber and Ultramarine Blue to sketch in the spikes of wet fur.

3 To complete the wet fur texture, Weirs highlighted the tips in the lighter fur with white and Raw Sienna and then added detail to the side of each wet spike using darker mixtures to indicate hairs drawing together to form each spike. In the darker fur, the shiny spikes of wet fur were highlighted with sky light using a mixture of white and Ultramarine Blue. Finally glints of pure white were added to give the fur a freshly wetted look.

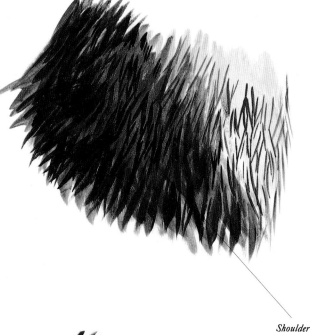

Shoulder

Bottom

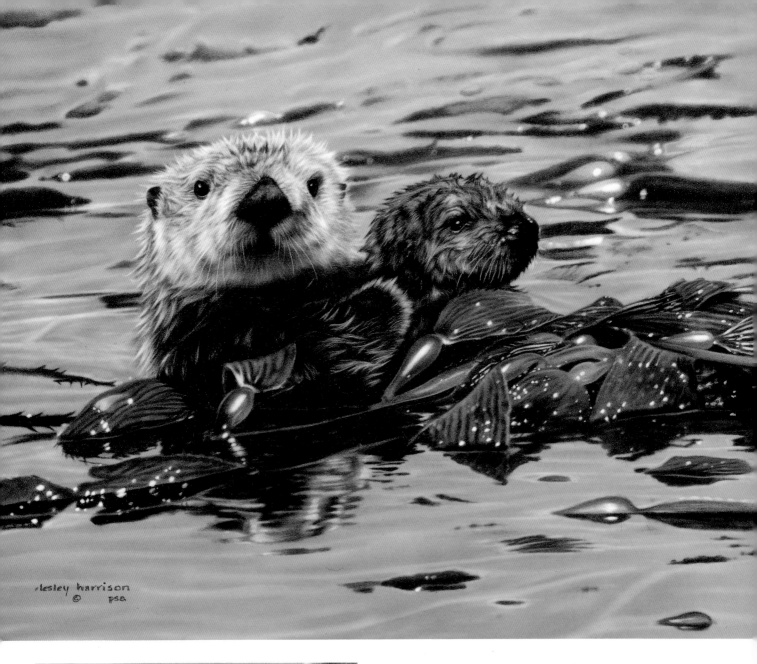

In Our Care, 16″ × 20″ (Sea Otters)
Pastel, Lesley Harrison

"Sea otters," says Weirs, "do not have a layer of fat below the skin, so they rely on air trapped in their very dense, soft fur to protect them from cold water."

DETAIL

CAPTURING THE PLAY OF LIGHT ON WHITE FUR

Many wildlife species such as polar bears, arctic foxes, harp seal pups and arctic wolves have thick, white fur that changes dramatically under different lighting conditions. In this demonstration, Weirs shows how to paint the effect of bright, low sunlight on the foreleg of a polar bear.

Location of polar bear fur demonstration

1 Weirs began by underpainting the blue edge on the shadowed side to indicate the effect of reflected sky light. Toward the front of the leg, where it's possible to see into the fur, she underpainted by adding Raw Umber to the blue used previously. On the sunlit side of the leg, she underpainted with a mixture of white, Raw Sienna and Mars Yellow to bathe the white fur in the golden glow of the sun—although, she notes, polar bear fur sometimes has a yellowish tint of its own.

2 To give the fur a denser appearance, Weirs added several more layers using the same colors as in Step 1 and short brush strokes. "I don't mix these colors on the palette," she says. "Instead, I dip my brush into each color separately to allow individual hairs to appear."

3 To complete the fur, Weirs added white highlights along the edges of the darker areas to give a greater feeling of depth and to indicate sun glistening off the guard hairs.

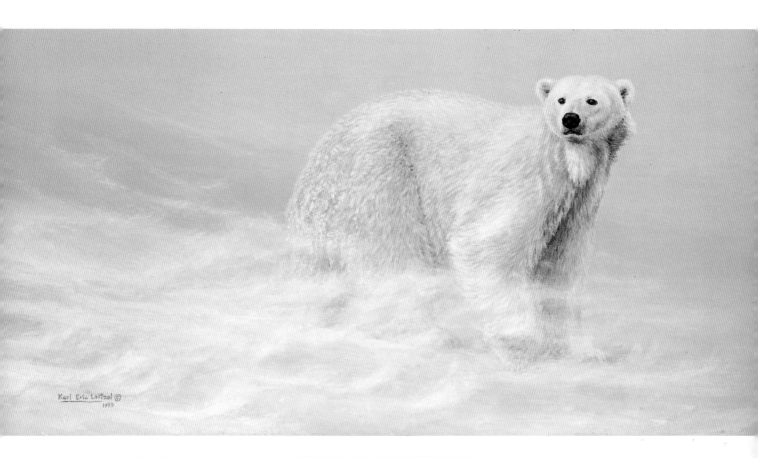

DETAIL

Great White Hunter, 12″ × 24″ (Polar Bear)
Acrylic, Karl Eric Leitzel
Collection of Larry J. Selfe

A polar bear's fur is composed of long,
coarse outer hair combined with a very
dense undercoat.

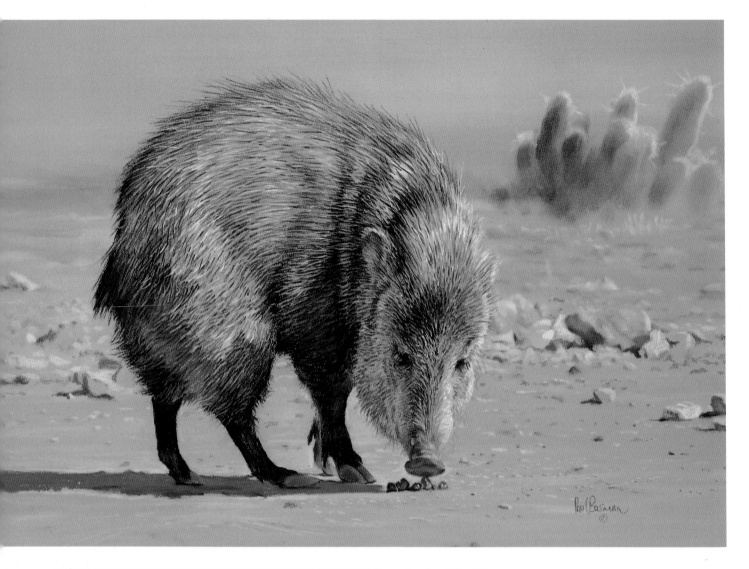

Javelina, 25″ × 29″
Pastel, Paul Bosman

Javelinas have coarse, brushlike hair.

DETAIL

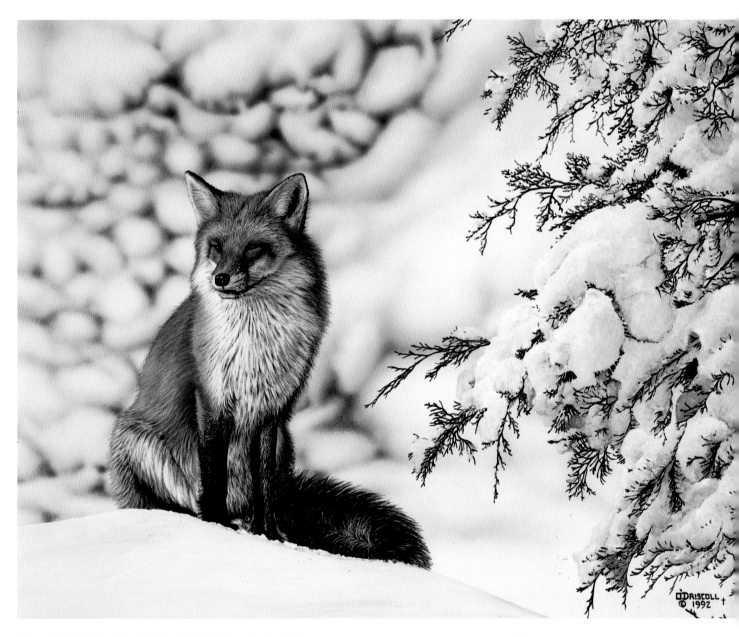

Fox, 18″ × 24
Acrylic, Danny O'Driscoll

Foxes have a wonderful variety of fur in their coat. It's fluffy around the neck, chest and shoulders, grading to smoother and more textured on the back. They have a very full tail with long guard hair and a thick undercoat.

DETAIL

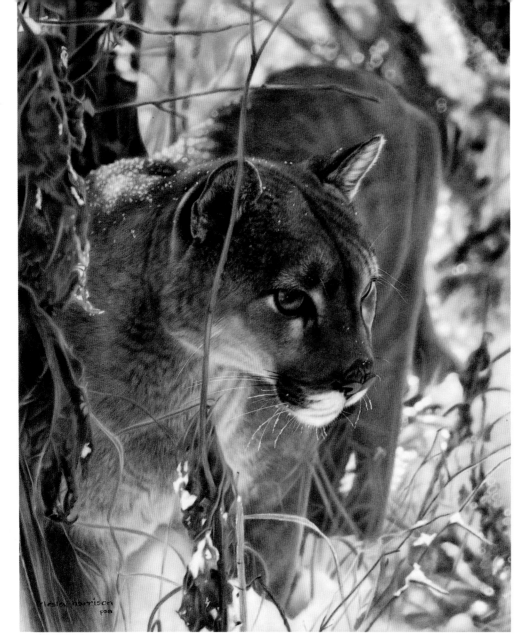

Icy Whiskers, 24″ × 18″
(Mountain Lion)
Pastel, Lesley Harrison

Mountain lions have rather stiff, short hair, and they grow an undercoat for winter in colder climates.

Seal 30″ × 40″
Oil, D. "Rusty" Rust

Seal fur is generally very fine, short and dense.

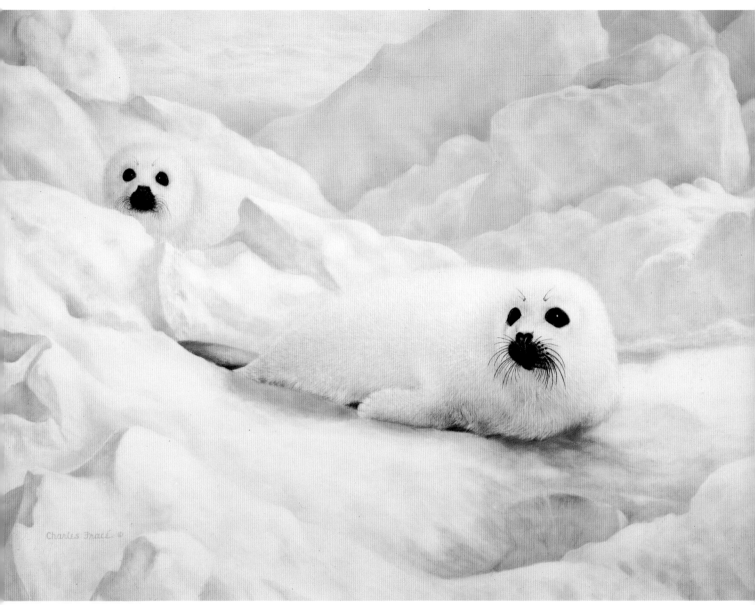

Peace on Ice, 18″ × 25″ (Harp Seal Pups)
Oil on canvas, Charles Fracé

Harp seal pups have transparent white hair in a beautiful,
dense, silky coat. The qualities of their coat trap heat from the
sunlight.

MASTERING THE ANATOMY OF WINGS AND FEATHERS

Wildlife art is somewhat unique among art forms in that it must answer to two masters: First, it must embody all of the classic art elements of design, composition and technical proficiency. Second, it must accurately depict the anatomy of the wildlife subject and its habitat. To satisfy the latter requirement, an artist should have a working knowledge of the subject—in this case, birds.

Most anatomical variations are evolutionary responses to a particular species' role in the greater ecosystem. The length and structure of a bird's beak, for example, reflects the nature of its food source—long, slender bills for sipping nectar from flowers or probing shallow waters; short, stout beaks for breaking seeds; pointed, downturned beaks for tearing flesh. Similarly, feet reflect adaptations for swimming, hopping, perching or walking. But of all these features, the physical characteristics we usually notice first are a bird's wings and feathers.

Sketch by Danny O'Driscoll

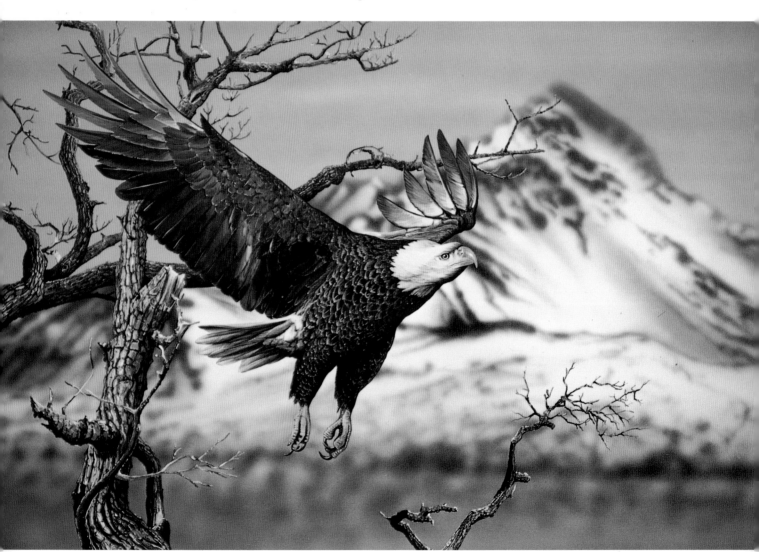

Bald Eagle in Flight, 24″×36″, Acrylic, Danny O'Driscoll

ANATOMY OF A WING

A close look at an extended wing reveals that feathers are grouped into "tracts" that vary according to the flight requirements of each bird species. The number, size and shape of the feathers in each tract are also distinctive for each species. Flight feathers, or primaries, radiate from a point roughly two thirds of the way between the wing root and tip. The area remaining between the wing root and primaries is occupied by secondaries, which are generally parallel to each other.

There are six basic wing shapes, adapted for the unique flying styles of different birds:

1. Short, broad and cupped for rapid takeoff and short distance flight (robins, for example).

2. Short and broad with slotted primaries for soaring flight (hawks).

3. Flat, moderately long, narrow and triangular for high-speed flight (terns).

4. Large, distinctly arched wings for slow, powerful flapping flight (herons).

5. Long, narrow, flat and pointed for gliding flight (petrels).

6. Short, pointed, swept-back wings for hovering (hummingbirds).

Take a look at Danny O'Driscoll's drawings of the anatomy of the extended wing of a red-tailed hawk as seen from above and below. You can locate the hawk's ten primary feathers, twelve secondary feathers, and the many feathers comprising its six lesser tracts.

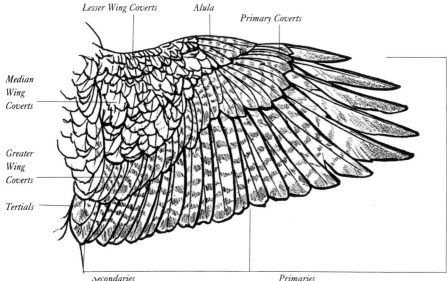

UPPER WING SURFACE OF RED-TAILED HAWK

Lesser Wing Coverts *Alula* *Primary Coverts* *Median Wing Coverts* *Greater Wing Coverts* *Tertials* *Secondaries* *Primaries*

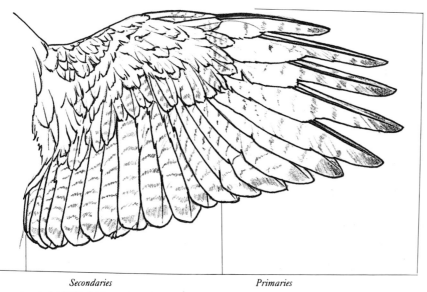

Secondaries *Primaries*

UNDERSIDE OF RED-TAILED HAWK WING

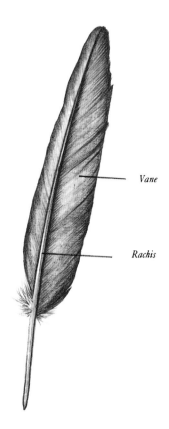

Vane

Rachis

ROBIN'S FEATHER. This robin's feather illustrates how a songbird's wing is short, broad and cupped for rapid takeoff and maneuverability among branches and vegetation. (Sketch by Danny O'Driscoll)

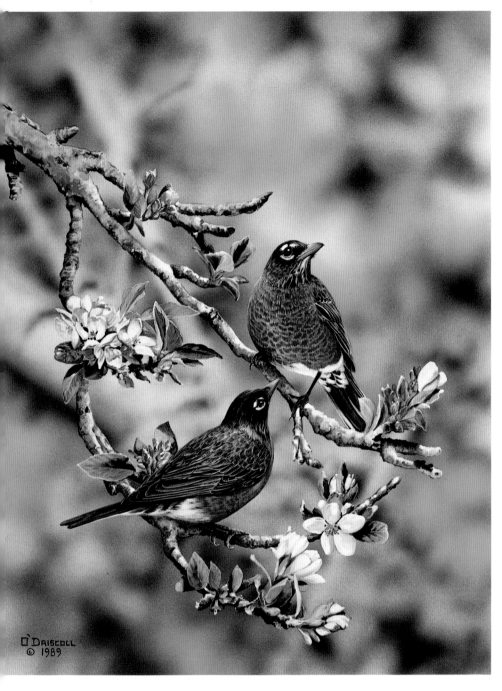

Robins and Apple Blossoms, 18″ × 14″
Acrylic, Danny O'Driscoll

ANATOMY OF A FEATHER

Although the size, shape and function of individual feathers vary greatly according to the species of bird and the feather's specific location on the wing or body, all feathers share a basic structure—a stiffer central shaft called a rachis from which the vane or flight surface of the feather extends left and right. The wing feathers of birds that spend much of their time flying while migrating or searching for food quite often overlap their tail feathers. In contrast, the wings of songbirds that fly shorter distances or must maneuver among branches and vegetation are typically shorter and more rounded at the tips. When a red-tailed hawk, for example, is at rest, its wing feathers extend about halfway down the length of its tail.

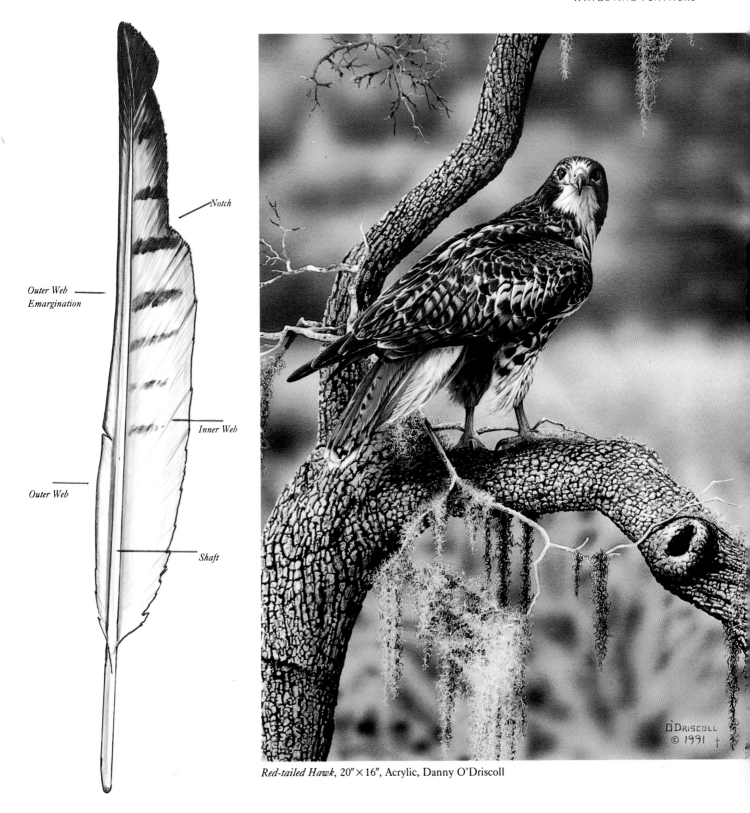

Notch

Outer Web
Emargination

Inner Web

Outer Web

Shaft

Red-tailed Hawk, 20″×16″, Acrylic, Danny O'Driscoll

RED-TAILED HAWK'S PRIMARY FLIGHT FEATHER. Like most large raptors, red-tailed hawks have a conspicuous slot or notch on each of their outer five primary feathers. This feature assures great stability in flight. Buteos, or soaring hawks, have short, rounded wings and long, broad tails that allow them to soar on thermals (rising currents of warm air) and gives them the incredible maneuverability and speed necessary to pursue prey in a variety of habitats. (Sketch by Danny O'Driscoll)

PAINTING WINGS AND FEATHERS

Once you understand their basic anatomy, painting wings and feathers becomes a relatively straightforward process. Using the red-tailed hawk wing as an example once again, Danny O'Driscoll shows in three steps how to develop a wing.

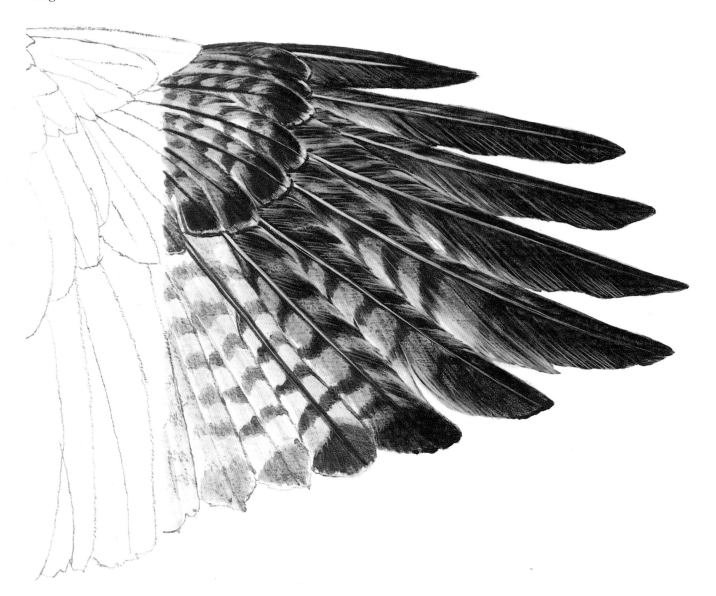

1 O'Driscoll began with a pencil drawing of the feather tracts, delineating the positions and shapes of each of the primaries and secondaries.

2 Next he rendered the vanes of each feather and the hawk's characteristic dark bar markings using washes of Mars Black and Ultramarine Blue. He added the darker shape of the rachis and highlighted it with Titanium White.

3 O'Driscoll next glazed the feathers with a pale wash of Burnt Umber. The lighter portions of the feathers are glazed with Acra Gold. Highlights were added where necessary to define separations between fibers in the vanes, and then additional glazes of Burnt Umber and Acra Gold were applied where necessary to darken shadows and build subtle variations of color.

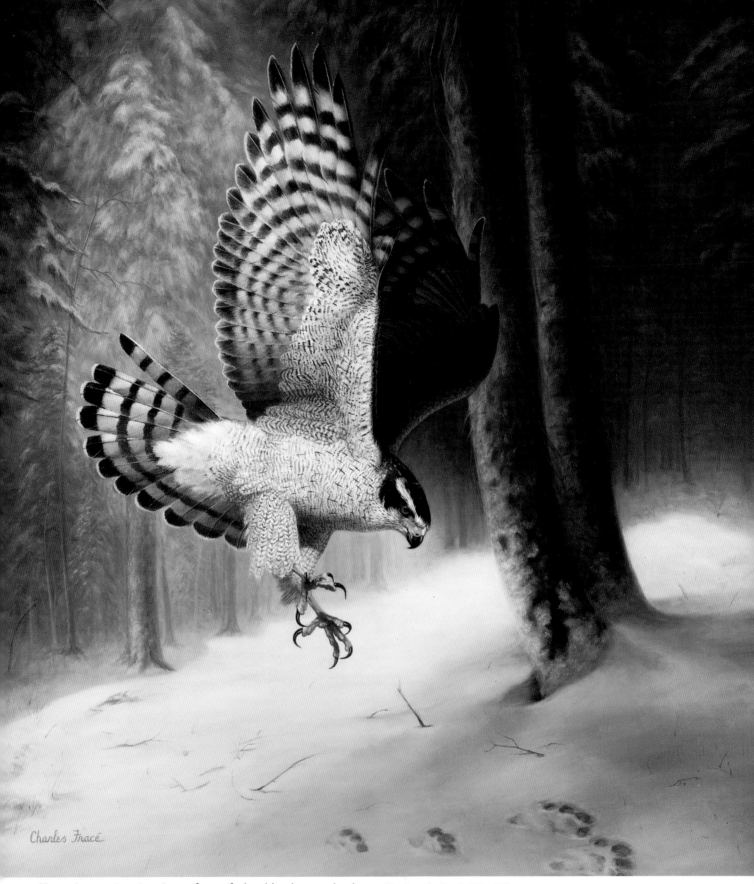

Charles Fracé

Here, the upper and under surfaces of a hawk's wing are clearly visible, as are the feather tracts on the upper surface. The five primary feathers pointing toward the top show the notch characteristic of large raptors.

Northern Goshawk, 30″ × 28″
Oil on canvas, Charles Fracé

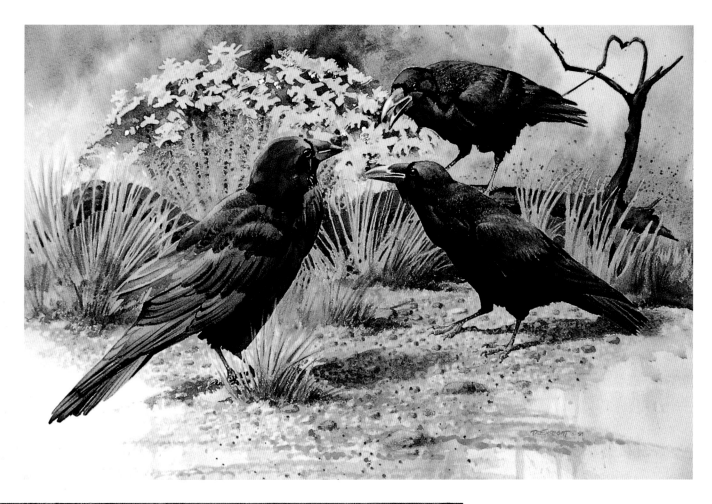

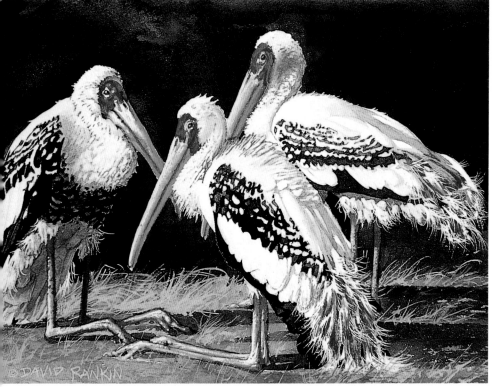

In Conference, 18″ × 24″ (Ravens)
Watercolor, Don Enright

Ravens are scavengers with strong, thick bills ideally suited for foraging. Their long, broad wings allow them to fly slowly as they search opportunistically for food.

Siesta, 8″ × 11″ (Painted Storks)
Watercolor, David Rankin

Storks have evolved long legs to facilitate their typical aquatic feeding habits. Using their long, slightly down-curved beaks, they probe wetland floors to stab or catch prey. Broad wings allow them to soar easily along migratory routes.

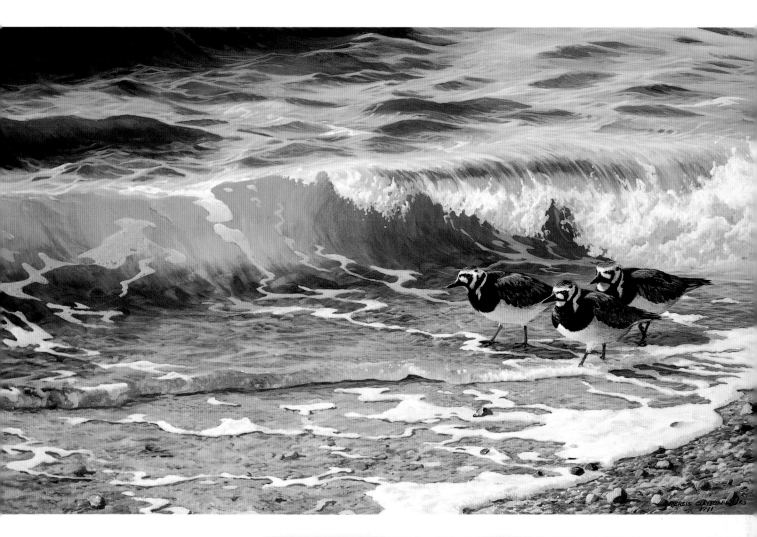

Ruddy Turnstones, 18″ × 30″
Acrylic, Persis Clayton Weirs
Courtesy of the artist and Wild Wings, Inc.

Ruddy turnstones are so-called because of their characteristic behavior of using their beaks to overturn stones, seaweed and other objects in search of food. Their short, slightly upturned beaks are ideally adapted for this purpose.

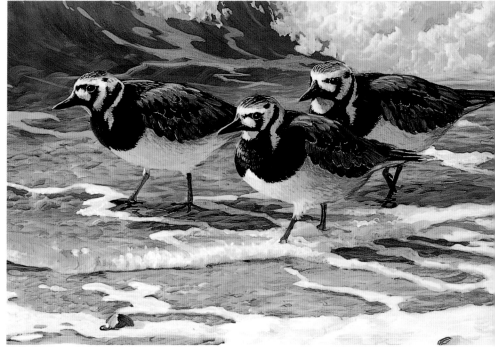

DETAIL

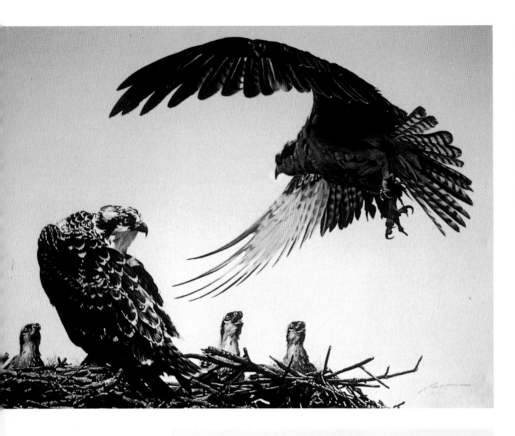

Osprey, 30″ × 40″
Oil, D. "Rusty" Rust

Although osprey feed entirely on fish, their feathers, feet and beaks have much in common with hawks. Ospreys' feet and sharp talons are especially adapted for scooping up prey or grasping it after plunging talons-first into the water. A noticeably longer "thumb" claw and sharp scales on the bottoms of their feet help hold just-captured prey securely.

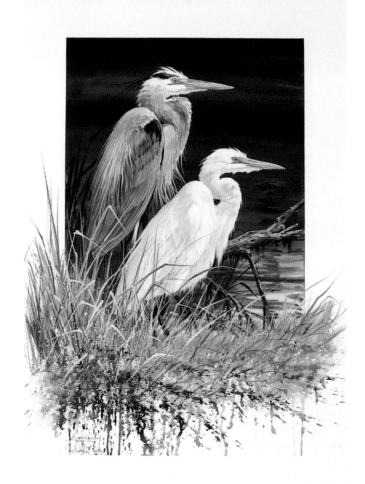

The King and I, 30″ × 20″
(Great Blue Heron and Great Egret)
Watercolor, Luke Buck

Both herons and egrets have long legs suitable for striding along wetlands while stalking small fish. Their height allows them to see prey more easily, and their long toes distribute their weight over a larger area, which keeps them from sinking into mucky wetland bottoms. Long bills allow them to pluck prey from shallows without fear of drowning.

Winter Secrets, 28" × 16"
(Ruffed Grouse)
Acrylic, Persis Clayton Weirs
Courtesy of the artist and Wild
Wings, Inc.

Primarily a ground feeder, a
grouse has short, sturdy
wings that are suitable for
brief, low-level flights; its
chickenlike feet are well
adapted for scratching out
food or for roosting in tree-
tops. Its elaborate tail feath-
ers are probably as impor-
tant for mating and
territorial displays as they
are for flight.

AQUATIC TEXTURES: SCALES AND IRIDESCENCE

Ganging Up, 18″×28″ (Smallmouth Bass)
Acrylic, Mark Susinno
Courtesy of the artist and Wild Wings, Inc.

The irregular dark markings on the smallmouth bass derive their shape from the underlying scale pattern.

SCALES

Even to the untrained eye, many fish species can be readily distinguished from one another via obvious anatomical differences such as shape of body and placement of fins. For certain similar-looking but completely unrelated species—such as smallmouth bass and wall-eyes—exact species identity can be most easily distinguished and conveyed by carefully observing and painting the characteristic sizes, shapes and patterns of their scales.

"If you're having difficulty achieving a fair degree of accuracy in the proportions of the scales you're attempting to paint," says Mark Susinno, "don't hesitate to use scale row and lateral line scale counts. The lateral line is

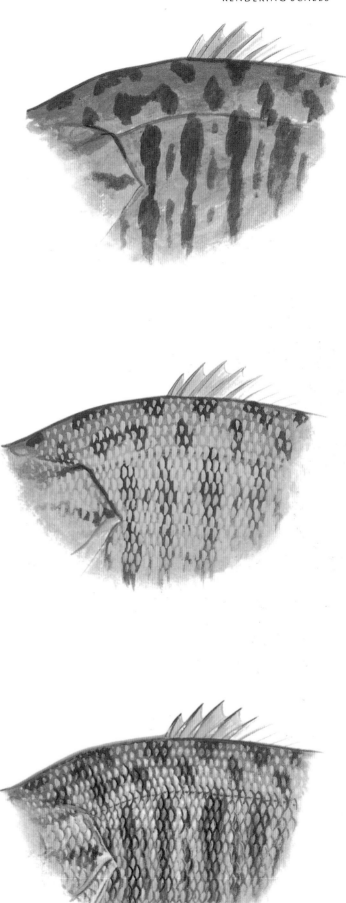

a row of scales with sensory pores that runs horizontally across the side of a fish from the head area to the tail and allows it to sense low-frequency vibrations such as those caused by a struggling baitfish. If the body proportions are accurate and the scales are painted in the proper numbers both vertically and lengthwise, then everything should be, almost automatically, in the proper proportions.''

RENDERING SCALES

To help you simplify the task of rendering scales, this demonstration shows how Susinno paints the scales for a smallmouth bass. These techniques will also work for other freshwater species with medium-sized scales such as largemouth bass, sunfish, perch, walleye, pike and muskie. They'll also work for certain saltwater species such as redfish, weakfish and bonefish.

1 To provide a suitable contrast for lighter dabs of color to be applied in the next step, Susinno began with a general undertone, somewhat darker than he wanted the final image to appear. Over this he applied the smallmouth's characteristic markings—darker vertical bands interspersed with various irregular splotches. "If you're at all uncertain, it really helps at this stage," he says,'' to have photographic reference of the pattern of markings.''

2 Next, over the underpainting, Susinno applied lighter dabs of color in rows to designate scales. "This method is much easier," he says, "than drawing the darker outline of the scales first." In smallmouth bass, as in most other members of the sunfish family to which it belongs, scales on and above the arching lateral line run parallel to it while those below it run more or less in flat, horizontal rows.

3 To complete the effect, Susinno outlined individual scales with darker colors. Then he applied dabs of lighter or more intense colors to various scales to give the impression of iridescence. Finally he applied additional washes where necessary, such as over the dark markings that had been lightened in Step 2. These final washes might also be applied to depict areas of light and shadow on the scales.

Irresistible, 16″ × 24″ (Muskie)
Acrylic, Mark Susinno
Courtesy of the artist and Wild Wings, Inc.

The scales on a muskie's flank are small
and lie in fairly straight, parallel lines.

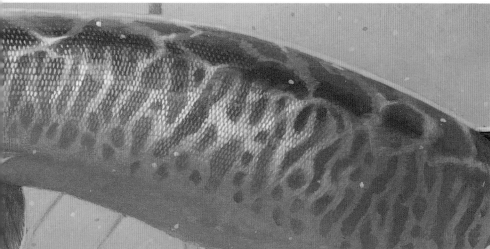

DETAIL

DETAIL

Panic, 12″ × 32″ (Walleye)
Acrylic, Mark Susinno
Courtesy of the artist and Wild Wings, Inc.

The scale rows on a walleye's flanks do not run parallel to the lateral line but rather run up to it at an angle.

IRIDESCENCE

Many species of fish have an iridescent appearance that is as captivating as it is beautiful. Iridescent paints may offer one solution for artists, but as Mark Susinno points out, iridescent paints do not reproduce well. This can make it difficult for anyone unable to view the original work to fully appreciate the subtlety of an artist's technique.

Therefore, in much the same way that still-life painters learn to create believable illusions of gold, silver and bronze without relying on paints created from those metals, Susinno suggests this alternative: Learn to create the illusion of iridescence in fish by contrasting specks of intense color against an underpainting of rather neutral, muted colors.

"Naturally," says Susinno, "you're more likely to create a believable illusion of iridescence if you've also spent time observing the phenomenon in live fish and have supplemented that knowledge by studying high-quality photographs."

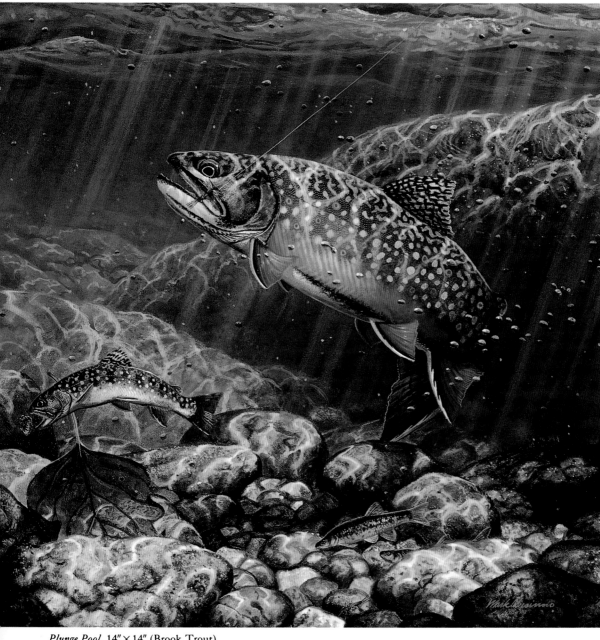

To capture the play of light on the lower sides of a brook trout, contrast intense yellow-orange areas against other areas of less intense orange-red.

Plunge Pool, 14″ × 14″ (Brook Trout)
Acrylic, Mark Susinno
Courtesy of the artist and Wild Wings, Inc.

RENDERING IRIDESCENCE

The following demonstration shows you how Mark Susinno approaches the challenge of iridescence when painting a rainbow trout's head.

1 Susinno began by blocking in the trout's basic background colors with muted neutrals: Olive Green for the top of the head and back; a cool, "dirty" pink for the cheek or gill cover area, and a purplish gray for the lower portions of the jaw and belly.

2 Next, he added slightly lighter but more intense colors to the cheek and lower jaw areas by stippling them with a fine-pointed brush and by drybrushing using the following colors and mixtures: Cadmium-Barium Yellow and Orange right out of the tube; Cadmium-Barium Red Light mixed with white; Perylene Red with white; Phthalo Blue with white and Dioxazine Purple with white. "Applying washes of color over the underlying colors will not work nearly as well," he says, "as placing purer dabs of color next to each other."

3 To refine the effect, Susinno continued adding light and dark flecks of intense color. "The iris of the trout's eye is also iridescent and reflective," he says, "so I apply strokes of various bright colors to give the iris life." Susinno completed the trout's head by adding its characteristic dark spots and by strengthening highlights.

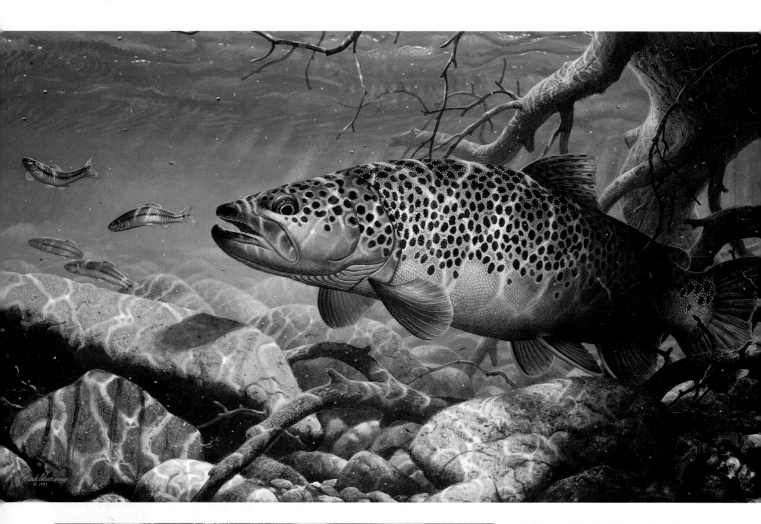

DETAIL

On Target, 14″ × 24″ (Brown Trout)
Acrylic, Mark Susinno
Courtesy of the artist and Wild Wings, Inc.

To simulate iridescence on a brown trout, paint the scales as dots of intense yellow on a rusty-colored ground.

(right)
The background color of a crappie's flanks might best be painted as dabs of pink, lavender, yellow and light blue against a more neutral ground.

Black Crappie, 19″×11″, Acrylic, Mark Susinno, Courtesy of the artist and Wild Wings, Inc.

6

PAINTING WILDLIFE STEP BY STEP

In previous chapters, you've seen how to gather and use a wide variety of wildlife reference materials; you've also learned how to apply a number of essential techniques for composing painting ideas, depicting habitat and creating authentic textures. Taken together, these techniques allow you to convey authentic details of wildlife and its habitat within a framework built on sound artistic principles.

 In this section, you'll have the rare opportunity to take an in-depth "look over the shoulders" of these top wildlife artists—a chance to see step-by-step how they bring together the techniques you've seen thus far. But perhaps the most important lesson you'll learn from this section is that regardless of the medium they work in, these artists think and build their paintings using the same basic building blocks available to you—good reference, a solid concept, a well-thought-out artistic composition and sound painting techniques.

Caribbean Reef, 22″ × 36″, Acrylic, Randall Scott

Demonstration One

COMBINING AN ANIMAL DRAWING WITH LANDSCAPE ELEMENTS

PAUL BOSMAN

O ne of the most common mistakes beginning wildlife artists make," says Paul Bosman, "is not having an animal looking as though it belongs in the picture. Very often, not enough thought has gone into placing the animal naturally and linking its tonal values and colors to the surrounding habitat. It's also important to get the animal's perspective correct so that it won't be alienated from its background."

Bosman accomplishes these goals in several ways. First, he becomes intimately familiar with his subject via personal observation and sketching. Second, he keeps an extensive library of 35mm slides. "I take my own reference photographs," he says, "because when I view a slide, I'm immediately taken back to the moment when I took the shot. I remember the time of day, the time of year, the circumstances relating to the particular incident and its outcome— everything from the smell of the dust to the sound of a stampede."

It is this kind of firsthand knowledge that provides Bosman with an understanding of animal gestures and helps give his paintings a feeling of substance and authenticity. When it comes time to paint, he makes certain that disparate elements from various reference materials work together as a cohesive image by settling on a consistent light source and using a well-coordinated palette to ensure unity of color and lighting throughout the image.

For *Oak Creek Bandit*, Bosman wanted to depict a raccoon's creekside hideout based on observations and sketches he'd made during frequent hikes in Oak Creek Canyon not far from his home in Arizona. Feeling that the flood-strewn brush and round pink and gray river stones along the water's edge would make an interesting study of colors and textures, he pulled out all the slides and sketches he had on file of creeks, riverbanks, trees, brush, stones, water and raccoons.

Original art—actual sketch used for Oak Creek Bandit.

1 THUMBNAIL SKETCHES. "After drawing a few quick thumbnail sketches," says Bosman, "I decided that a sketch of a raccoon placed in the upper third segment on a diagonal line had potential, as long as I left enough space between the lair and the water to include some of those attractive stones."

2 COMPOSITION SKETCH. Next, using a piece of layout paper about half the size of the final image, he carefully drew the composition with a 2B pencil, positioning the elements in an interesting arrangement and getting an idea of the overall dynamics and tonal values.

"I wanted to place some brush debris along the riverbank in the upper-left corner to lead the viewer's eyes to the raccoon's face," says Bosman. "Then, they'd move down to the turbulence in the water, which is where the raccoon's attention would also be focused. Overall, the movement in the painting would be in a **Z**-shape with the viewer's eyes returning to the focal point—the raccoon's face."

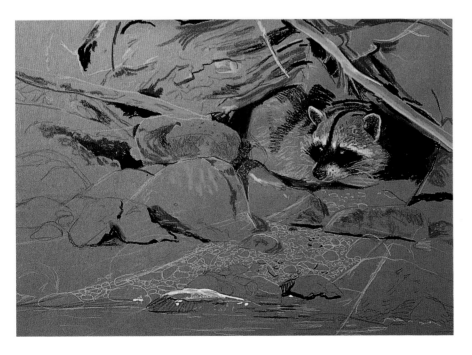

3 BLOCK IN. Bosman drew each of the elements onto a sheet of cork-colored Canson pastel paper. "I chose this color," he says, "to provide an overall warm tone in keeping with the red rocks of the Sedona area." Using pink and black Carb-Othello pastel pencils, he lightly drew each of the elements. "My intention was to keep the top third of the painting in shadow and the lower two-thirds in sunlight, with the light coming from about ten o'clock." With this in mind, Bosman began drawing the raccoon using black and a small amount of white to establish its tonal range, and stick pastels to introduce additional colors.

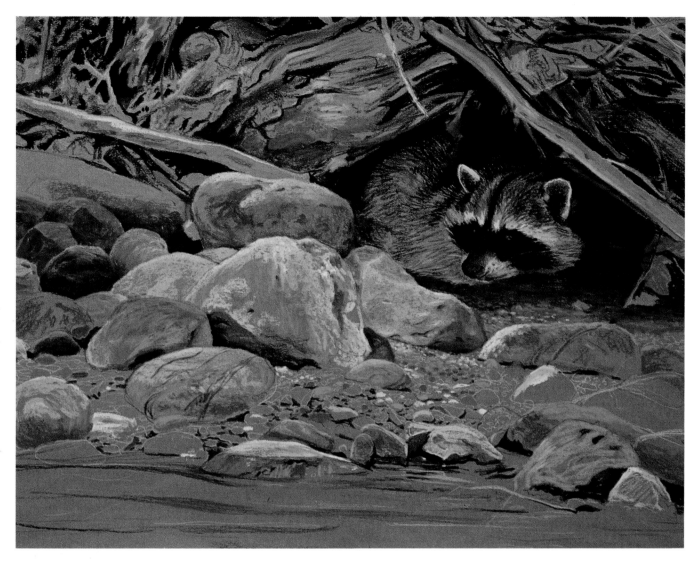

4 MORE COLOR. Bosman continued developing the entire image (except for the water) using a palette of Rembrandt stick pastels. To draw attention to the raccoon, he used more black on it than anywhere else and blurred edges of elements in the background. The larger blue-gray stones in the foreground were positioned to break into the Z composition for interest while the smaller reddish-tan stones were intended to subtly reinforce the Z movement. "Other than a little finger smudging here and there," he says, "colors were applied in fairly strong pastel strokes, sharpening details in the raccoon with pastel pencils."

BOSMAN'S PASTEL COLORS

- Permanent Red Deep
- Mars Violet
- Light Oxide Red
- Burnt Sienna
- Caput Mortuum Red
- Indian Red
- Burnt Umber
- Red Violet Deep
- Gray
- Bluish Gray
- Mouse Gray
- Ultramarine Deep
- Black
- White

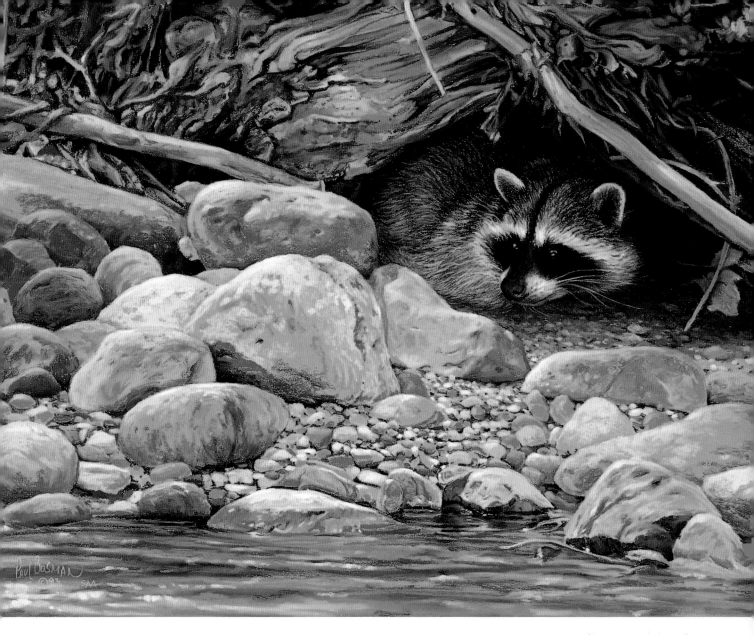

Oak Creek Bandit, 19½″ × 25½″
Pastel on Canson paper, Paul Bosman

Original sketch used as basis for Oak Creek Bandit.

5 FINISHING DETAIL. As he worked toward completion, Bosman allowed the paper color to show through as much as possible to unify his colors. He interspersed the warm-toned rocks, with grays as well as both warm and cool colors on individual rocks. "Juxtaposing warm and cool colors also has a pleasing effect whether used in elements of the composition or simply as strokes of color in close proximity." Finally, the foreground water was indicated and blurred slightly to direct the viewer's attention toward the more sharply focused raccoon.

Once Bosman had essentially completed the painting, he put it away for several weeks. "When I looked at it again," he says, "I decided it needed softening generally and that the small stones needed brightening. I added a few drips of water on the larger stones because I wanted viewers to think about the role of predator and prey. What was the raccoon watching that had caused the slight turbulence in the water? Were those wet foot marks on the rocks? Had he tried a few moments before and failed?"

Demonstration Two

EMPHASIZING DETAIL WITH LOOSE BRUSHWORK

LUKE BUCK

If every element in a painting is in the same sharp focus, it's difficult for any one element to stand out dramatically. As a result, many realist artists use a soft-focus background to direct attention to a subject placed in the foreground. The technique is effective but often imparts a somewhat photo-realistic quality to the image. To overcome that photolike appearance and to give his work a more

painterly feeling, artist Luke Buck has taken this idea a step further: "Since I like both realism and impressionism," says Buck, "I'll often combine these two styles by painting the wildlife subject realistically while rendering the landscape or background more loosely."

Beyond this, Buck feels that each painting should tell something about its subject or at least about the situation—whether the bird or animal is startled, in motion or quiet.

"To me, great blue herons seem to have an attitude—like they're the King of Birds and know it. I wanted to convey that feeling through the heron's stance and also by putting more emphasis on the bird and less on the detail around him."

To create *Great Blue Heron*, he selected a vertical piece of Crescent cold-press watercolor board and masked off a 1½″ border across the top, about halfway down each side and across the bottom. The unmasked portions of the border reflect Buck's painterly approach: by only partially masking the side borders, he's able to "break" the edges of his paintings with grasses, water or other elements, thereby creating an interesting design while adding depth and excitement to the image.

1 INITIAL DRAWING. With the borders masked, Buck sketched the heron onto the watercolor board with an HB pencil while referring to a photograph he'd taken in Florida. "Having painted for most of my life," he says, "I already knew what I was going to do. Even so, I sketched the heron extensively because I like having a lot of information before I begin. If I don't need as much detail, I can always erase; if I need more, I can always add it." Buck also indicated the grasses and foreground elements but with considerably less detail. Finally, he applied a heavy coat of liquid masking fluid to the heron so the dark background could be painted freely over it.

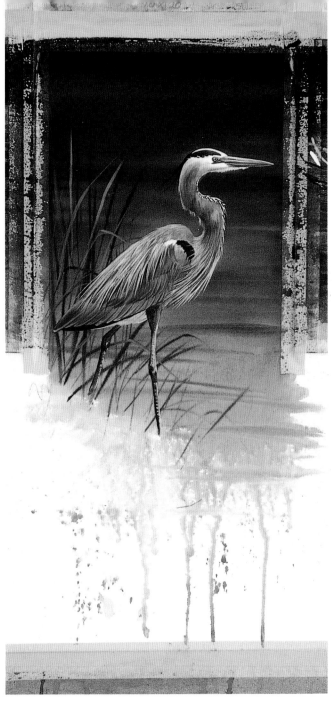

2 **BACKGROUND.** Since the heron was mostly blues and grays, Buck settled on a variety of muted greens and browns for the background. He applied the graded neutral wash with a 1-inch aquarelle brush, working from top to bottom. As he neared the bottom, he added Cerulean Blue to the mixture, causing the color to gradually shift to a pale muddy blue. Next, while the wash was still wet, he loaded his brush with fresh pigment and spattered it onto the board from the tips of the bristles, then immediately picked up the watercolor board and slammed it on his work table to make the paint run toward the bottom. To help the paint flow into interesting patterns, he spattered clean water into the wash.

Using the same brush, he worked back and forth across the wash to break up the vertical borders and create streaks of dark and light suggesting water or other diffuse details. Finally, with the paint nearly dry, he returned with several values of gouache to indicate the first grasses.

3 **PAINTING THE HERON.** With the masking removed, Buck prewet the heron's form and, starting at the head, worked wet-in-wet using Cerulean Blue, Naples Yellow, white, Brown Madder Alizarin and Sepia, varying mixtures as necessary but keeping Cerulean Blue in each of them so that colors would remain atmospheric and chalky.

Buck concentrated on building a sense of roundness and form without worrying greatly about detail. As the paint dried, he used a light-value gouache mixture (white and Cerulean Blue) to paint the feathers on the heron's back and side. He then painted the legs with mixtures of Burnt Sienna, Sepia, Cerulean Blue and Yellow Ochre. Next, he painted around the heron's eyes using Cerulean Blue and Sepia. For the eyeball and beak, he used Golden Yellow.

To complete the heron, he painted the pupil and dark outline around the eye, added a highlight on the eye and beak, and painted the black "cap" atop the heron's head.

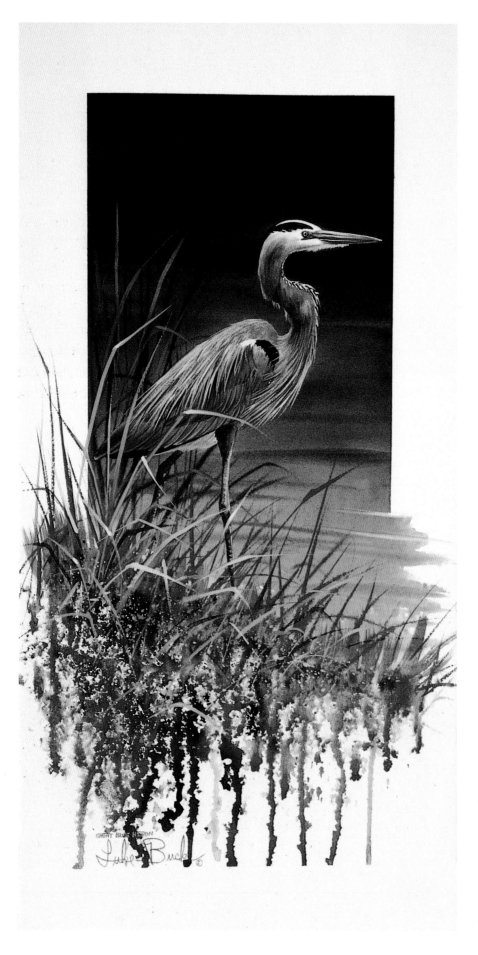

4 FINISHING DETAIL. With the background and heron complete, Buck removed the masking tape from the top and sides but left the bottom strip in place. "As I painted the foreground," says Buck, "I deliberately crossed the side borders to break up the hard edge, but I wanted to keep the bottom border crisp because I felt that a break there would have made the image seem bottom-heavy."

Using a ¾-inch aquarelle brush with bristles splayed and a middle value of Green Oxide, Buck indicated the first of the foreground grasses with upward strokes and then accented and sharpened some of them with a no. 4 rigger brush. To keep the bottoms of these strokes from ending abruptly, he loaded his brush with Sepia and spattered it at the base of the grasses, then repeated the process with other colors he'd used thus far. To help the spatters disperse in interesting patterns, he lifted the watercolor board, banged it against his work table and observed the result before proceeding.

To complete the foreground, he added a few sharply defined grasses using several mixtures of light green gouache, then spattered once again with more of the same green mixtures. Finally, he spattered a variety of purples, reds and yellows at the base of the grasses to suggest wildflowers.

"Ideally," says Buck, "a wildlife painting should not only appeal to wildlife lovers but to art lovers as well. So, when it comes to my paintings, I'm an artist first—my goal is to create reasonably accurate renderings of my wildlife subjects without compromising artistic principles to achieve absolute accuracy."

Great Blue Heron, 20″ × 10″
Watercolor, Luke Buck

Demonstration Three

BUILDING DEPTH AND ATMOSPHERE WITH FALLING SNOW

KARL ERIC LEITZEL

In *Eyes on the Prize*, artist Karl Eric Leitzel wanted to depict a pair of gray or timber wolves intent on the hunt, in a misty atmosphere that mutes colors and obscures details. Scenes such as this must surely take place nearly every day in a wolf's life, but few humans have the opportunity to witness them firsthand. Leitzel combined his extensive knowledge of Canadian gray wolves with reference photographs obtained while visiting the wolves' native habitat near Algonquin Provincial Park in Ontario, Canada.

Leitzel began by assembling photographs he'd taken of captive gray wolves at a refuge near his home in Pennsylvania. Since the wolves were kept in a large fenced enclosure where they could run freely, he felt that his reference accurately reflected their natural postures. After checking with another wildlife artist who had observed these wolves in the wild, he made a mental note to adjust their coloration to a lighter, redder pattern that would more accurately portray the wolves of eastern Canada. To complete the scene, he referred to photos of landscape elements he'd taken earlier near the park. Using all these materials, he drew several pencil sketches to work out the composition.

Next, Leitzel prepared a piece of ¼″ untempered Masonite by brushing on three coats of gesso, sanding lightly between coats. He drew the profile of each wolf to scale on cardstock and positioned them on the panel. Satisfied with the position and overlap of the wolf shapes, he traced around them lightly with a 4H pencil and sketched the other elements of the composition.

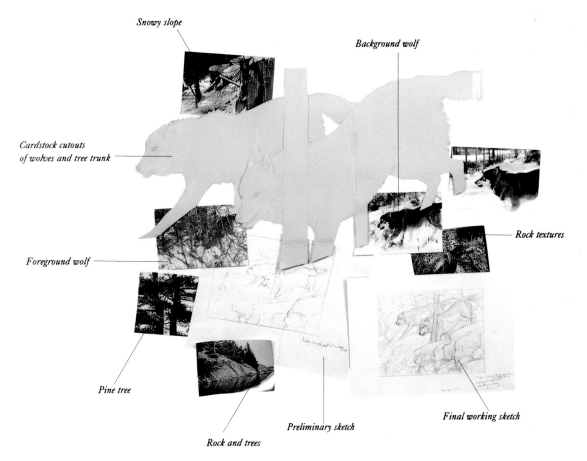

Snowy slope

Background wolf

Cardstock cutouts of wolves and tree trunk

Rock textures

Foreground wolf

Pine tree

Final working sketch

Preliminary sketch

Rock and trees

Reference material for *Eyes on the Prize*: sketches, reference photographs, and cardstock cutouts of full-sized wolf profiles and tree trunk for positioning.

1 BLOCKING IN THE FORMS. Using a light neutral gray mixed from Titanium White, Burnt Umber and Ultramarine Blue, Leitzel blocked in the sloping snow and suggested contours using a ¾-inch white "sable" nylon (a nylon brush with white hairs that simulate the characteristics of a natural sable brush) flat brush. Then, using a slightly lighter shade warmed with Yellow Ochre, he blocked in the sky and added warm notes to the closest parts of the snowy slope.

Continuing to work with the ¾-inch flat brush, Leitzel blocked in the rocks and trees using lighter and darker variations of the basic gray mixture. Contrast was strengthened in the foreground rocks and the jack pine trunk with additional Burnt Umber and Yellow Ochre. The wolves were still unpainted.

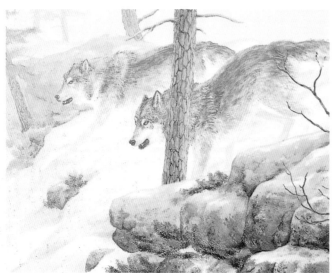

2 ROUGHING IN THE WOLVES. Leitzel refined the sky, background rocks, trees and snow-covered slopes with additional applications of the same neutral gray mixtures.

Next, the wolves were roughed in using the same gray mixture enhanced with some richer color. Facial details were added using a ⅛-inch flat white "sable" nylon one-stroke lettering brush. "Because of the atmosphere in this scene," says Leitzel, "black facial details had to be painted using a medium gray mixture of white, Burnt Umber, and Ultramarine Blue." Burnt Sienna was added for redder areas of the wolves' coats and for the nearest rocks and tree trunks.

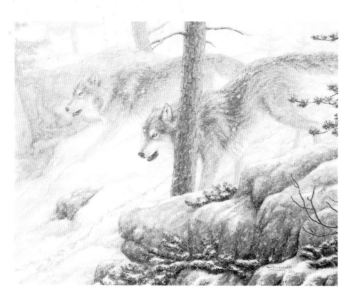

3 REFINING AND ADDING SNOWFLAKES. Fur textures were suggested with thin layers applied with a stiff, old, sparse-bristled brush. Sometimes, a fingertip softened edges and textures. Some more saturated color was added selectively for sparkle. Unsatisfied with the rear legs of the foreground wolf and the twigs in the upper-right corner, Leitzel tested new possibilities with paper cut-outs before painting out the legs and twigs to be replaced by new versions.

"To create the random speckling of snowflakes," says Leitzel, "I dabbed a 1¼-inch hake brush straight into Titanium White, lightly coating the ends of the hairs with stiff white paint." Then, dabbing the brush on the painting, he changed the angle often to keep the pattern random and renewed the paint frequently to obtain the desired effect. Small, fairly saturated notes of Prism Violet, Ultramarine Blue and Burnt Sienna were added selectively to shadows, snow, rocks, tree trunks and wolves to give the image a subtle pointillistic sparkle.

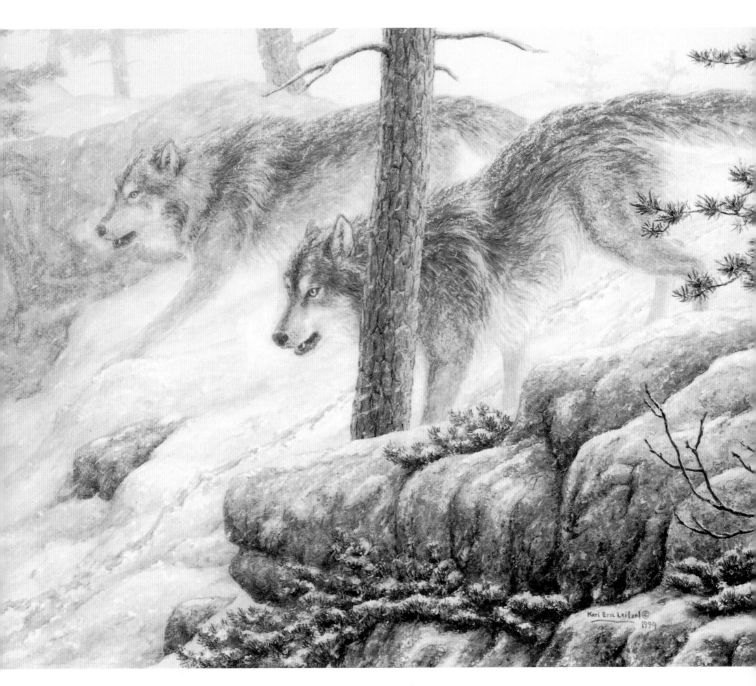

4 ADDING PUNCH. In addition to getting the anatomy and habitat correct, part of the challenge of this painting was to make certain that every element had the correct amount of "atmosphere" to recede to its proper place within the illusionistic depth of the scene.

After setting the piece aside for a few days, Leitzel decided that it needed more punch, which he added by increasing the color, contrast and detail of various elements in the foreground. The increased punch slightly reduced the sense of falling snow and atmosphere, but overall, Leitzel felt he'd achieved a good balance between atmosphere and detail.

Eyes on the Prize, 22″ × 28″
Acrylic on gessoed panel, Karl Eric Leitzel

Demonstration Four

UNDERSTANDING AND PAINTING ANIMAL BEHAVIOR

DON ENRIGHT

I grew up with a fondness and fascination for the outdoors in general and for wildlife in particular," says Don Enright. "After attending art school, I went into advertising and eventually ended up working for a firm based in the foothills of the Colorado Rockies. There, I had the opportunity to observe Rocky Mountain bighorn sheep on many occasions." Enright documents many of his first-hand observations with slides as well as black-and-white photographs. "One of the most difficult aspects of painting wildlife," he says, "is getting good reference of the subject in motion. For me, a Nikon F3 with a motor drive and a 43-86mm or 300mm telephoto has helped considerably."

Pencil thumbnail sketch for Courting

Enright supplemented and expanded his own observations and photographs of the bighorn's anatomy, movement and behavior by watching wildlife videos, reading sporting magazines, joining interest groups such as the Foundation for North American Wild Sheep, and studying books such as the *Guide to Game Animals* by Leonard Lee Rue III, *Animals in Motion*, by Eadweard Muybridge, and *Animal Anatomy*, by Ellenberger.

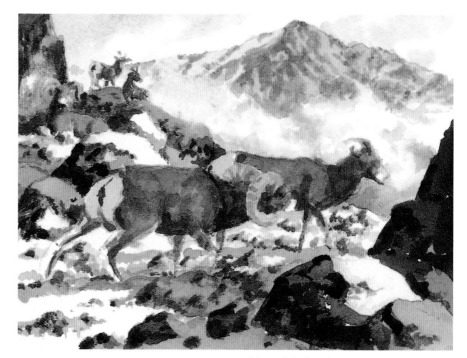

Color study for Courting

To bring his personal experience and acquired knowledge together in his paintings, Enright first completes small thumbnail sketches and color studies to work out the concept, composition and values. The concept for *Courting* was to accurately portray the bighorn's typical environment as well as its characteristic posture when courting during mating season.

"This scene is set among granite boulders at around the nine to ten thousand foot elevation," says Enright. "Most of the year, the older rams tend to run in bachelor groups, but during mating season—October through early December—they actively search for suitable mates. When they encounter a comely ewe, they court by approaching with head down and neck extended, as I've shown in these sketches and in the final painting."

1 BLOCKING IN WITH PALE TINTS.
After completing detailed drawings of each of the bighorn sheep, Enright enlarged them onto his 300-lb. Arches cold-press watercolor paper using an opaque projector. Then, he lightly sketched the details of the mountains, rocks and snow patterns. After taping the edges of the paper to a board Enright painted the sky and distant mountains with a no. 12 red sable brush using mixtures of Cerulean Blue, Payne's Gray and Cobalt Blue. "I wet the surface of this area before putting down any color," he says, "in order to create soft edges where the sky and clouds met."

Next came the foreground colors in relatively pale tints of Ultramarine Blue, Alizarin Crimson and Raw Umber for shadow sides and Raw Sienna on the sunny side. Snow shadows were also indicated at this point using mixtures of Payne's Gray and Cobalt Blue.

2 INTENSIFYING THE COLORS. Using no. 7 and no. 8 red sable brushes and the same colors, Enright carefully intensified the colors and refined the details of the foreground elements.

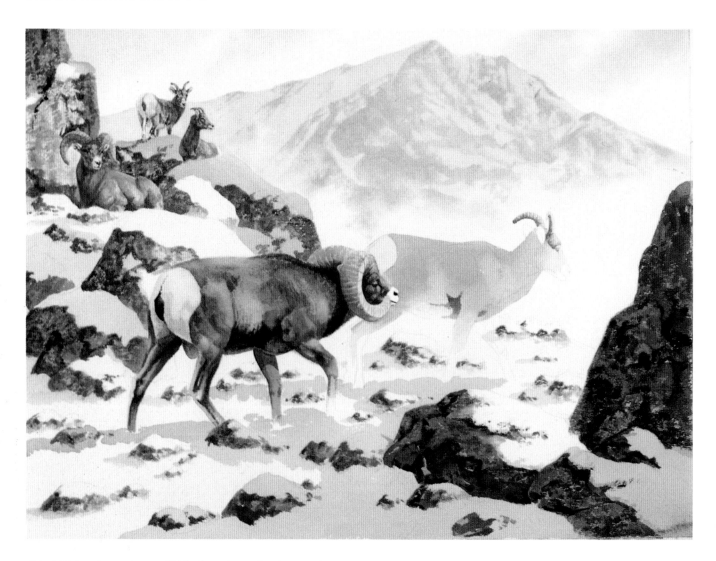

3 PAINTING THE SHEEP. With the primary landscape elements painted, Enright began painting the bighorn sheep. The horns were laid in with a no. 7 red sable using mixtures of Raw Sienna with a touch of Cadmium Yellow Pale for the sunlit sides; shadow sides were painted with various mixtures of Raw Sienna, Ultramarine Blue and Alizarin Crimson. Details were added using a no. 3 red sable.

The sunlit sides of the ram's neck were painted with Burnt Sienna and Cadmium Yellow Pale, which gradually transitioned into a shadow side mixture of Burnt Umber and Ultramarine Blue. The ram's and ewe's bodies were rendered with a no. 7 red sable using mixtures of Raw Umber modified with Ultramarine Blue and Alizarin Crimson. As the forms turned into shadow, this mixture was cooled with more Ultramarine Blue and Alizarin Crimson. The ears were painted using mixtures of Davy's Gray warmed with Cadmium Yellow Pale for the sunlit areas and cooled with Payne's Gray for the shadows. Details of the sheep's nostrils and tails were then rendered with a no. 3 red sable and Payne's Gray.

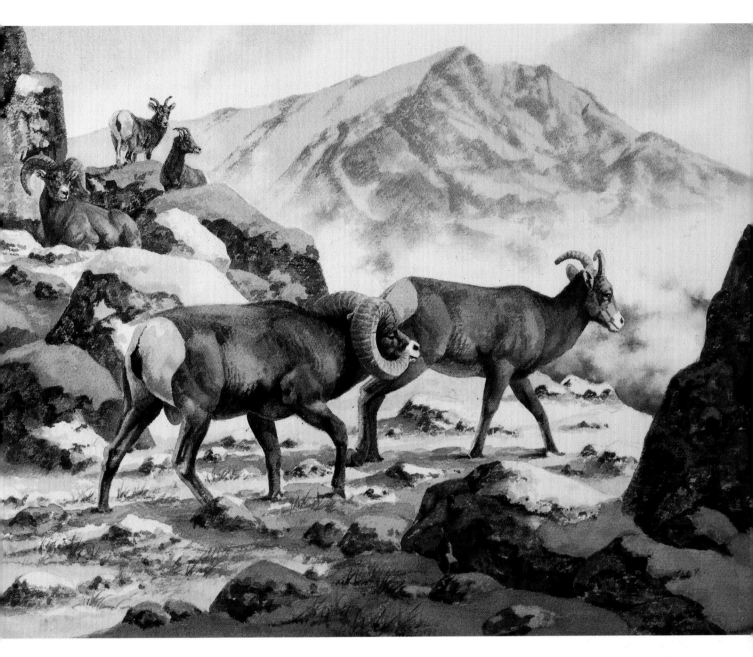

4 **DETAILING THE LANDSCAPE.** To complete the painting, Enright strengthened shadow areas in the snow using a no. 7 brush and various mixtures of Payne's Gray, Cobalt Blue and Alizarin Crimson. Then, with the same brush and mixtures of Raw Sienna and Olive Green, he added wisps of grass showing here and there through the snow. Shading was added to the grasses with a no. 3 brush and mixtures of Ultramarine Blue and Alizarin Crimson. Finally, Enright added a few warm notes to the snow with a mixture of Cadmium Red and Cadmium Yellow Pale.

Courting, 17″ × 23″, Watercolor, Don Enright

Demonstration Five

TAMING WILDLIFE WITH PASTELS

L E S L E Y H A R R I S O N

Pastels aren't usually the first medium that comes to mind when people think of wildlife art, and as California artist Lesley Harrison will tell you, pastels are no more magical than any other medium. "There's no secret," she insists, "just lots of hard, painstaking work that most people never see. When I paint, I just sweat over every detail until the painting is finished."

In *Against the Wall*, Harrison set two dueling stallions against a backdrop of pictographs on a rock wall to suggest the idea that wild horses have been fighting to establish dominance for as long as the species has existed. Thus, the context is deliberately ambiguous—this timeless battle for dominance could have taken place sometime in the distant past or only yesterday.

To paint these stallions, Harrison worked from a number of slides she'd taken of a group of about fifty wild mustangs a local woman had adopted. "I've ridden domestic horses most of my life," says Harrison, "but the demeanor of these wild stallions is unlike any domestic horse I've known—they emanate the same feeling of defiant independence I've sensed when I've been in the presence of wolves, lynx and mountain lions."

1 PLANNING THE COMPOSITION. Harrison used gouache to paint a quick study of the rock wall and pictographs (based on her own reference photographs) on a sheet of clear acetate. "I tried to work out the details on acetate first," she says, "because pastel on velour paper doesn't allow for a lot of major changes." She placed an outline of the two stallions drawn on tissue over the acetate to determine the best compositional balance. "The horses are 'cut off' because it places viewers close to the action and helps them see these two powerful stallions as living, breathing animals."

2 THE DRAWING. Next, Harrison drew the outlines and key details of the two stallions onto a sheet of colored velour paper. From her extensive collection of pastels, she selected a single pastel stick for each nuance of color in the painting. This eliminated the need to blend colors and allowed each pastel to contribute its full vibrancy to the image. For this painting, she selected a range of gray-browns, light grays, dark burgundys, oranges and a few blacks, mostly from her sets of Nupastel and Girault pastels.

3 **THE PICTOGRAPHS.** Slowly, she laid in the gray-brown background tones and then carefully rendered the pictographs. "Once I'd painted the pictographs over the background rock wall," says Harrison, "I realized that they didn't show up enough, so I later strengthened them with blacks and dark burgundys as well as splashes of orange and other lighter colors."

HARRISON'S FAVORITE PASTELS

- A 500-stick set of Sennelier pastels ("soft, even consistency and extensive range of golden and red-browns")
- A 300-stick set of Quentin de la Tour pastels ("strong in pink, yellow and peach hues")
- Holbein ("harder, but still considered soft")
- Grumbacher ("big set, wonderful range of colors")
- Nupastel ("hard sticks, good for detail")
- Schmincke
- Rembrandt
- Conté

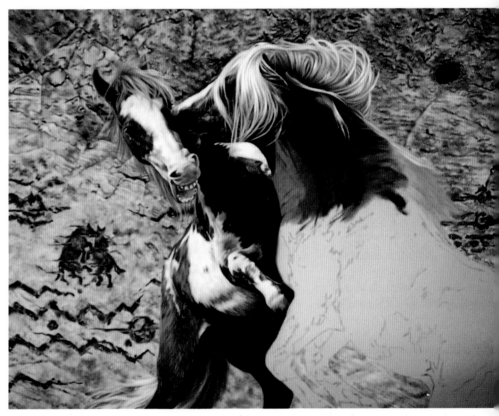

4 **BLOCKING IN THE STALLIONS.** With the background complete, Harrison turned to the two stallions. "I wanted to make them a really strong center of attention," she says.

She began by blocking in the pinto's shape using medium values of the dominant color for each area of his body. Then, over this base of color, she modeled his contours using progressively darker values before returning with higher values to establish lighter areas and highlights. "Since I was working on beige-colored paper," she says, "I put a warm gray under the whites to keep them from becoming muddy. I also lightened the pinto's tail more so it would contrast better against the rock wall."

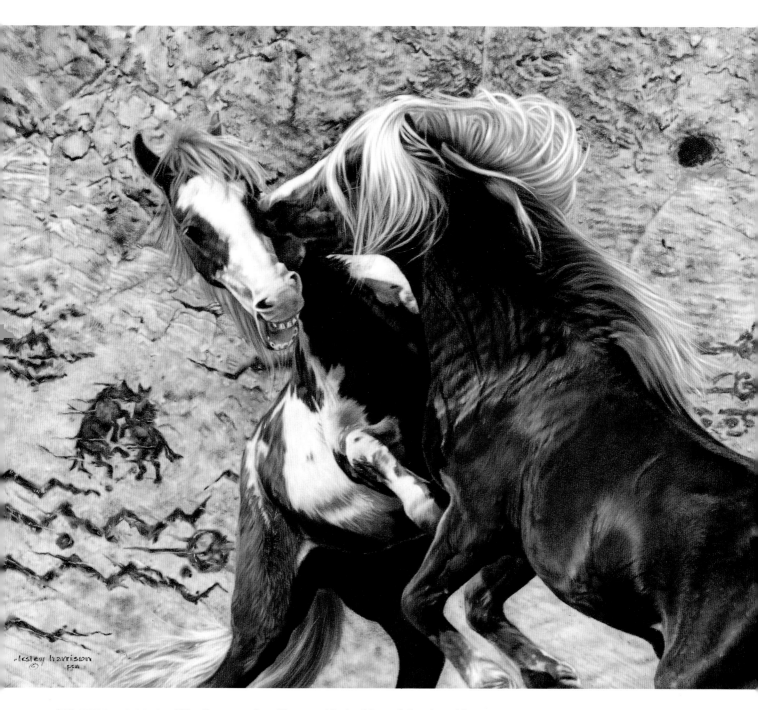

5 BUILDING COLOR. The foreground stallion was blocked in and developed in a similar manner. "I used about eight colors to build up the color of his coat," says Harrison. "I began with a Medium Red-Gold and went over it with a Deep Brown and then a Mars Violet. Then, I added a different reddish gold and some black before returning with highlights of bright oranges, pale grays, light golden white and a brighter white to pop it back up."

To complete the painting, Harrison adjusted colors and values until she was satisfied with the image. "Although the horses were based on photographic reference," she says, "I used a lot of artistic license to make them stronger and more vibrant by eliminating things that didn't work and adding things that did."

She refrained from using fixative between layers or over the completed image because it would have deadened or changed the rich and delicate nuances of color she'd worked so hard to capture.

Against the Wall, 16″ × 20″
Pastel on velour paper, Lesley Harrison

Demonstration Six

PAINTING WILDLIFE IN COMPLEX BACKGROUNDS

BART RULON

Good wildlife art always starts with a good idea," says Bart Rulon. "Something in the painting must be outstanding—the lighting, the composition, the action, or the way in which the image conveys the character of the animal. For *Hunting in the Everglades—II*, I worked from a number of photographs I'd taken while visiting Everglades National Park in Florida."

His compositional plan was to use two intersecting branches to guide the viewer's eyes to the green heron, which was to be partially obscured by several lily pads and grasses. The bird would blend into the complex background pattern of surrounding vegetation, much as it would in nature.

This plan allowed Rulon to bend a generally accepted rule of composition by placing the heron near the center. To be certain of the best position for the bird, he cut out its shape on a piece of paper and then moved it around on the gessoed Masonite panel to find the optimum location before sketching it permanently in place.

During the first painting session, Rulon's goal was to cover the entire surface of the panel with paint (with the exception of the heron). "The most important thing to establish right away," he says, "is the color balance of the entire painting. Judging color correctness is much easier once the white of the panel has been mostly covered and surrounding colors have been established for comparison."

THUMBNAIL SKETCHES. "As I mulled over the concept for the painting, I drew a series of thumbnail sketches to work out the composition and identify my strongest reactions to the scene," says Rulon. In the end, what struck me most was Florida's brilliant light and deep shadows, lush vegetation, and the play of light and shadow on the heron as it stalked in and out of my sight through the tangle of lily pads, grasses and weathered branches."

1 BLOCKING IN THE MAIN COLORS
Rulon blocked in the main colors with relatively flat tones that he then developed further by painting darks such as the lily pad's shadows and the cracks on the bark. "I use the largest brushes possible for each task," he says, "so I can get the white of the panel covered as quickly as possible."

2 COMPLETING THE BACKGROUND ELEMENTS. "When painting plants," Rulon says, "pay special attention to the subtle variations of green that make them believable. To accomplish that, I usually mix the colors for one lily pad at a time to avoid having the same greens on every leaf. In addition, I mix plenty of the base color for each leaf because I use it for mixing all the lighter and darker areas of the same lily pad."

To complete the branches, he underpainted the lightest sunlit areas with pure Titanium White, then glazed them with thin washes of color.

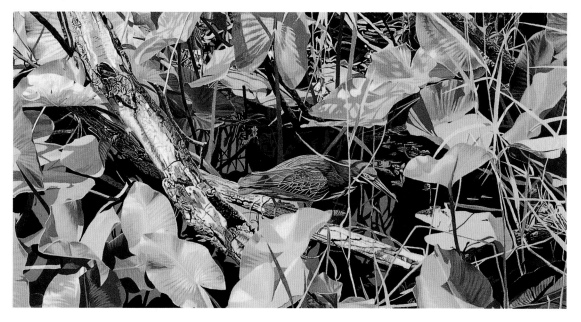

3 PAINTING THE HERON. Rulon blocked in the plumage using middle values of Ultramarine Blue and Burnt Sienna, then painted the darkest areas on the bird's underside, working back and forth to blend the dark areas and middle tones. The bare gesso provided a base white for the light feather edges.

"For sunlit areas such as the heron's back," he says, "I added progressively more white and Azo Yellow Light to the initial middle value color as I worked toward the brightest highlights." Then, after dulling the white streaks on the underside of the heron's neck where they were in shadow, he applied a thin glaze of light green and yellow over them to suggest the effect of color reflected from the nearby lily pads.

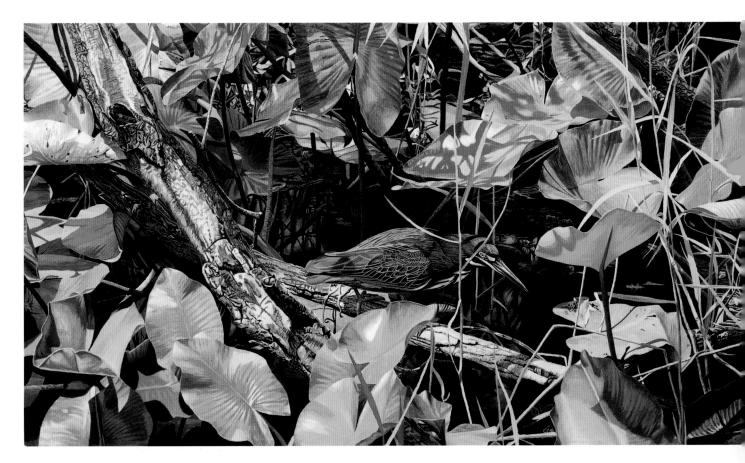

4 **REFINING THE DETAILS.** To complete the painting, Rulon added finishing touches to the heron's eye by glazing Brilliant Yellow straight from the tube around the edges of the eye. As he neared the pupil, he modified the initial color by adding Azo Yellow Light and white to give the eye its spherical form.

"At this point," he says, "I often photograph a painting to look at it on a smaller scale so that it's easier to spot and correct faults in color balance." After examining the resulting slide, he felt that some of the lily pads were too yellow and that there was a minor anatomy problem with the heron's wing. After correcting the contours of the wing feathers, he changed several of the lily pads to a darker green and darkened some of their cast shadows. He also darkened the heron's head slightly with

a mixture of Ultramarine Blue, Titanium White, Raw Umber, Mars Black and a touch of Azo Yellow Light. Finally, he warmed the branches with glazes of Raw Umber and Raw Sienna muted with Ultramarine Blue and white to create a more sunlit feeling.

"Deciding when an image—especially a very detailed one such as this—is done is a difficult thing," says Rulon. "In general, I consider a painting finished when the addition of more paint or detail will not get my point across any more effectively than the image does already."

Hunting in the Everglades—II, 17½″ × 34″
Acrylic on panel, Bart Rulon

Demonstration Seven

PAINTING UNDERWATER SCENES FROM REFERENCES

RANDALL SCOTT

To create successful paintings of underwater wildlife," says Randall Scott, "artists must not only understand composition and painting techniques but must also know their subjects intimately. I maintain an extensive library of books and magazines, but it is the photographs, notes and sketches I've assembled from personal observation when diving, sailing or boating that are my most valuable resources. Good reference materials help assure that anatomic details are correct, but it's really not terribly important whether or not you paint every scale and hair or only suggest them. What is important is that you 'get inside' your subject to give viewers a firsthand sense of life and emotion."

Getting good underwater reference material may mean enduring rough seas, cold weather, poor visibility, malfunctioning equipment and strong, unpredictable currents as well as mastering the art of underwater photography—not to mention learning to use camera equipment to ward off overly curious subjects such as sharks.

For *Sand Shark*, Scott's concept was to juxtapose a female blacktip shark against a downed WWII fighter—in this case, a relatively rare P-51 Mustang bearing the shark's smile that many associate only with the P-40 War Hawks made famous by the Flying Tigers. "The blacktip swimming overhead provides an interesting counterpoint," says Scott, "since many fighter aircraft were designed after the streamlined shapes of animals such as this shark—the fuselage is like its body and the wings are like its pectoral fins."

1 SKETCHING FROM REFERENCE SOURCES. Working from a variety of reference sources, Scott first drew a small pencil sketch to establish the location and proportions of the elements. Details of the P-51 Mustang were based on photographs he'd taken at an air show augmented by considerable historical research. The body position of the blacktip shark was based on a slide of a blue shark in a similar posture he'd taken off the Pacific coast. The blue shark's pectoral fins and body were longer and more slender and its nose more pointed, but Scott's knowledge of the differences between the two species allowed him to quickly make the necessary adjustments.

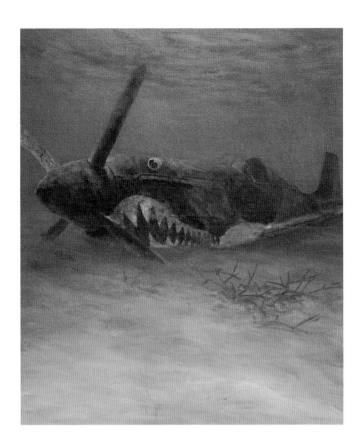

2 **CREATING THE ATMOSPHERE.** First Scott mounted a piece of linen canvas onto a plywood-like panel known as MDO board using acrylic gel medium. Next, he prepared the surface with several sanded coats of gesso. He then began underpainting broad areas of the panel to set the tonal and color key for the image. Once the resulting peach color seemed right, he blocked in the downed fighter using Burnt Sienna for the propeller cone and "mouth" and using smaller flat-bristle brushes and various mixtures of Raw Sienna, Burnt Umber and Ultramarine Blue for the fuselage and camouflage.

Next, he scumbled in various mixtures of Phthalo Green and Raw Umber along with mixtures of Cobalt Green muted with a small amount of white to give the water a more atmospheric feel. "By painting thinly and letting the underpainting show through," says Scott, "I could combine colors to give both vibrancy and a feeling of light filtering through sediment suspended in the water." Over this, he scumbled the first dappled indications of refracted light playing over the fuselage using a mixture of Cadmium Orange and white.

3 **PAINTING THE SHARK.** Then, while referring to his sketch and the reference photo of a blue shark, Scott drew the shape of the blacktip shark directly onto the panel with a pastel pencil, making corrections as necessary by wiping away unwanted lines with a damp rag. "I prefer this method over laying acetate sheets on top or moving tracing paper around," he says, "because I prefer the directness of working with the original drawing without any intermediaries." Once satisfied with the drawing, Scott quickly blocked in the shark with ¼-inch flat-bristle brushes using various mixtures of Payne's Gray, Raw Umber, and a small amount of Titanium White.

When he started the painting, Scott had planned on using bits of staghorn coral on the left side. He later realized that this coral was not native to the Mediterranean where this plane would have operated. Nevertheless, he felt he needed something emerging from the sand for interest. After more research, he determined that a type of seagrass native to the Florida Keys was similar to grasses that might be found in the Mediterranean where he'd set this scene.

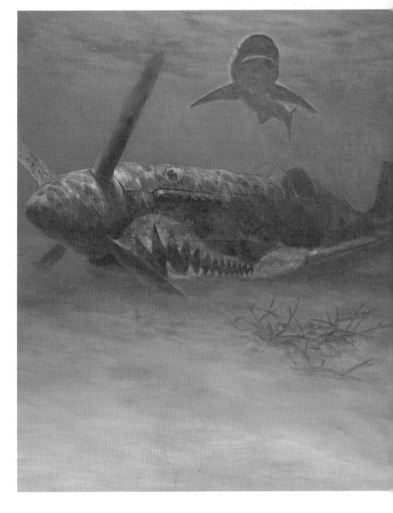

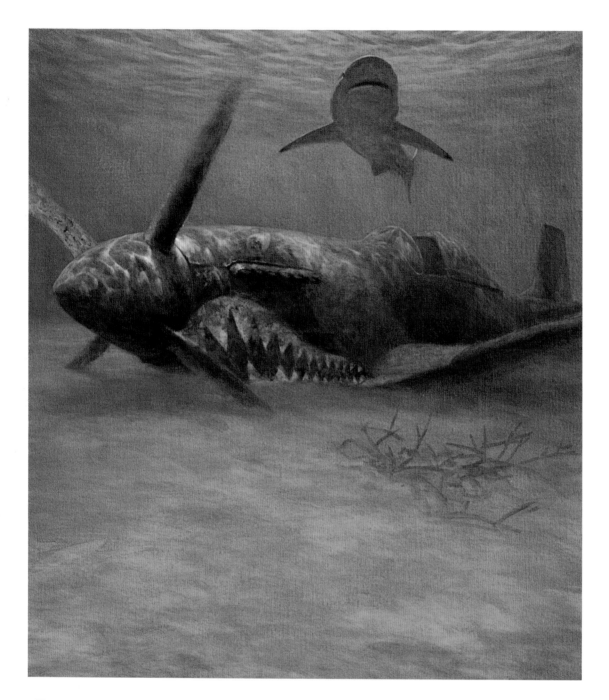

4 **EXPERIMENTING WITH REFRACTED LIGHT.** The shark's underside was modeled further with semitransparent scumbles of Cobalt Green, Raw Umber and Raw Sienna to produce a gray tone with flashes of purer color to suggest light and color reflected from below. In a similar manner, Scott modeled the underside of the water's surface with various colors including Raw Sienna and a lighter tint of green. "The undersurface of the water acts like a series of lenses and mirrors," he says, "focusing light like a magnifying glass or prism and reflecting light and color from below."

Referring to photos showing bands of light on the bottom and on various sea creatures, he experimented with accidental shapes and effects for the refracted light shimmering over the fuselage. "I made a number of strokes of light across the nose and fuselage," he says. "If I got an interesting shape, I left it; if not, I rubbed it off immediately."

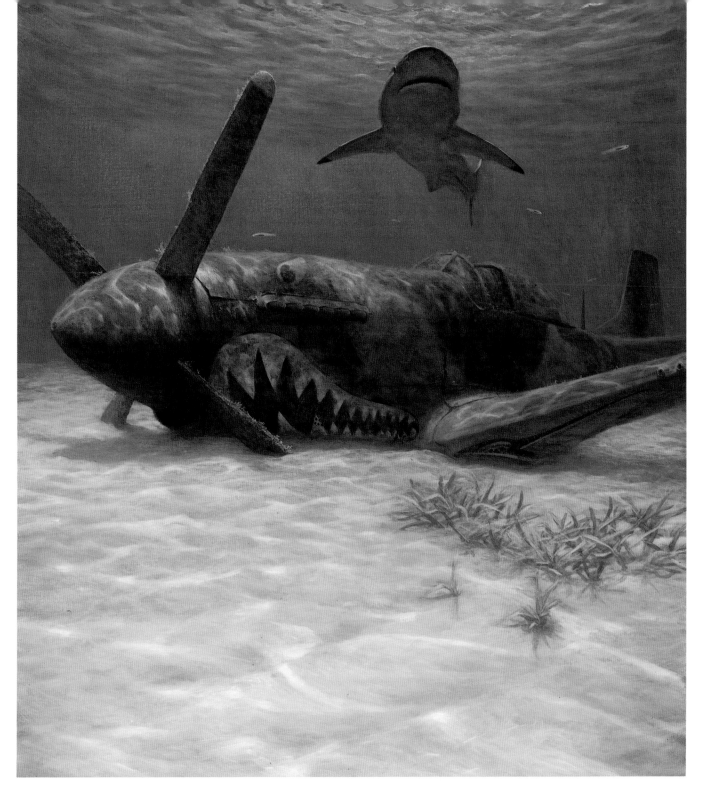

5 REFINING LIGHT AND SHADOW. Using reference slides he'd taken in the Florida Keys, Scott began developing the rippled pattern of sandy ridges and troughs by alternating light and shadow on the bottom around the aircraft. He then overpainted them with grayed mixtures of Phthalo Green in the distance, gradually warmed to a mixture of Cobalt Green with a little Raw Sienna in the foreground. Over this he developed the play of refracted light on the sandy bottom by scumbling "squiggled" patterns using a mixture of Cadmium Orange and white. "Burying the plane in the sand," says Scott, "gave it a somewhat ominous feeling in this tranquil setting of light dancing across the shifting sand."

Next came the aircraft's shadow. To get a better idea of how it might fall, Scott faced a spotlight toward a box of sand in which he'd carefully positioned a plastic model of a fighter.

Finally, after adding still more blue to the water overhead to suggest sky seen through its lenslike surface, Scott added several small fish swimming in the shark's vicinity. "These rainbow wrasses moving away seemed to acknowledge the shark's power and authority," he says.

Sand Shark
31¼″ × 26⅞″
Acrylic on linen
Randall Scott

Demonstration Eight

CAPTURING THE PERSONALITY OF BIRDS

D A N N Y O ' D R I S C O L L

Once you've mastered the technical skills," says O'Driscoll, "the most important part of painting is research—learning not only what a bird looks like, but what is unique in its behavior." So, before beginning a painting, he spends many hours in the field with camera and sketchbook and many more hours poring over books, magazines and other reference works, getting a feel for each bird's characteristic habitat, postures and behaviors.

Then O'Driscoll attempts to come up with a scene that captures some unique aspect of his subject's personality. In the case of the Carolina wren, O'Driscoll has completed a series of paintings, each depicting different facets of the wren's life and behaviors. In a prior painting, O'Driscoll depicted an adult attending to a young wren as it learned life's *first* lesson—feeding.

In this demonstration painting, *2nd Lesson,* O'Driscoll wanted to depict a young wren's second most important survival skill—learning to be alert to danger and reacting properly. When an adult sounds the alarm, a young wren must become instantly motionless and quiet to avoid attracting the attention of predators.

O'Driscoll sought to convey the feeling of spring by using an airbrush to create a soft-focus background. Against this, he set the wrens amid the barren branches of a turkey oak tree in the grip of a jessamine vine and its yellow blossoms. "Compositionally," says O'Driscoll, "I positioned the wrens above and below center and just slightly to the right or left. I also used various shapes in the background and foreground as subtle pointers."

O'Driscoll's sketches of a young Carolina wren (above) and an adult (below).

1 **AIRBRUSHING THE BACKGROUND.** O'Driscoll began by airbrushing various values of thinned Ivory Black acrylic onto a gessoed hardboard panel, leaving some areas lighter to suggest highlights and lighter objects in the distance. He then established shadows with thinned Ultramarine Blue, followed by applications of Hooker's Green, Burnt Umber and Cadmium Yellow Medium. Finally, the hint of sky was added using a color mixed from Ultramarine Blue, Phthalo Blue and Titanium White.

When the background had dried, O'Driscoll sketched details of the turkey oak and spiraling jessamine vines directly onto the panel and began working with conventional brushes. "My brushes vary from 00s to no. 5s," says O'Driscoll, "but I use a no. 3 the most, tapering or flattening it to achieve the desired effect. I prefer natural hair brushes even though acrylics on panel wear them away a lot faster than synthetic brushes."

Using a blue-black mixture, thinned as necessary to produce a range of values, O'Driscoll established the shadows. (Look closely at the vine to see what this stage looks like.) Then, with various mixtures of Titanium White and Ivory Black, the highlights and midtones were painted.

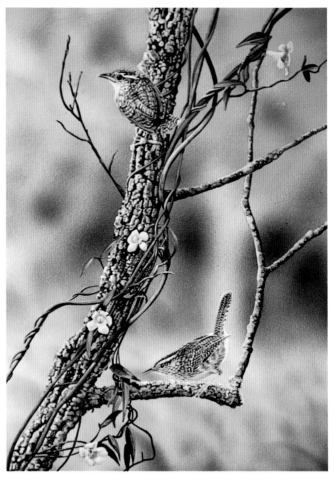

2 **BLOCKING IN THE VINE.** Next, the black-and-white value block in of the vine and blossoms was completed in the same manner as for the branches and bark. "The blue-black allows me to concentrate solely on establishing values and shading in my subject," says O'Driscoll. "Where necessary, I apply Titanium White over it to soften edges or to lighten overly dark areas of the background that show through the transparent paint. Even so, I always allow some of the background to show through. This integrates the colors of the subject with the background and keeps the subject from appearing stuck-on."

3 **GLAZING COLOR.** With the basic value structure of the tree, vine and blossoms established, O'Driscoll began glazing color onto each of these elements using Burnt Umber, Ultramarine Blue, Hooker's Green and Cadmium Yellow Medium. Where necessary, he mixed Titanium White with these colors wet-on-wet for easier blending. When glazing in this manner, O'Driscoll uses color straight out of the tube, thinned with water to the desired consistency.

When the glazes of color on the branches, vines and flowers had dried, the wrens were sketched lightly onto the panel and rendered initially as a range of values in Ivory Black, then refined using various mixtures of Titanium White and Ivory Black for the highlights and midtone values.

2nd Lesson, 16" × 21"
Acrylic, Danny O'Driscoll

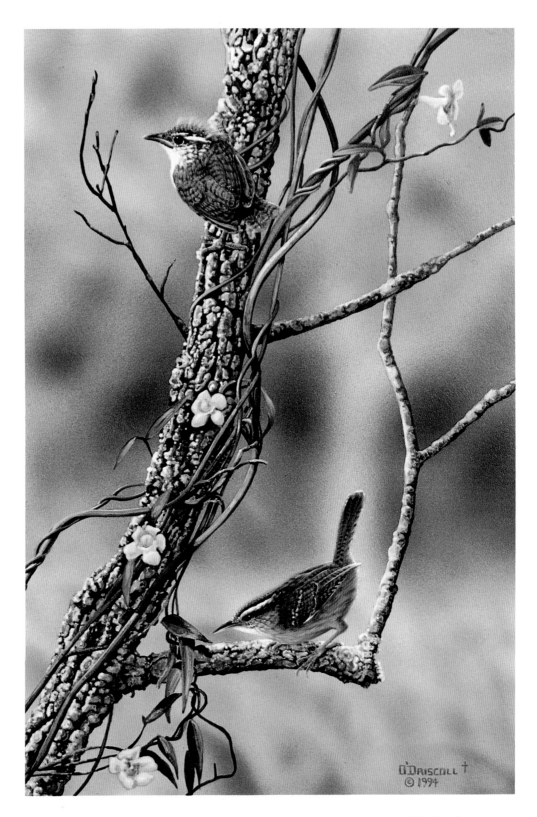

4 **PAINTING THE WRENS.** With the value block in of the wrens complete, O'Driscoll
added color in transparent layers beginning with the birds' eyes. "Once I've
painted the eye and its highlight, the subject really comes to life," says O'Driscoll.
Finally, O'Driscoll completed the image by glazing colors over the value block ins of
the wrens using Burnt Umber, Burnt Sienna, Cadmium Yellow Light, Yellow Oxide,
and Acra Violet for the birds' feet and the vines.

Demonstration Nine

LEADING THE EYE WITH LIGHTS AND DARKS

D. "RUSTY" RUST

We are taught early in life," says Rust, "to begin reading a page at the top, then work our way down, moving from left to right. So, when planning a composition, keep that lifelong pattern in mind and help your viewer by giving his eyes a path of strong contrasts to follow."

In addition, paintings can be planned around any number of value or tonal plans. The most common are these: high key (light values throughout), low key (darker values throughout) and middle key (middle values with no strong light or dark accents). "Quite often," says Rust, "a painting lacking one of these three values (light, middle, or dark) will seem unfinished. A foggy scene might be painted quite effectively in light and middle values while a night scene might be rendered with middle and dark values. But, if you want to add punch or accent, add a spot of the missing third value—a dark eagle in the foreground of the foggy scene or a bright light somewhere in the dark night scene."

With those two ideas in mind, Rust began planning *Ring-necked Pheasants* by drawing a series of four charcoal sketches, each about 5″ × 10″. "I knew I wanted the painting to be rather dark," says Rust, "so it wasn't too important that some of the sketches were lighter than the others—my main concern at this point was composition. By the time I'd reached the last sketch (no. 4), I'd realized that the barn wasn't so important after all and decided to put more emphasis on the pheasants."

Four charcoal sketches for *Ring-necked Pheasants*.

1 COLOR STUDY. "There are no colors that I always use," Rust says, "however, a limited color palette usually produces a pleasing effect. For artists who like using a lot of color, a 'mother color' (one color added to all the other colors on the palette) usually helps assure a satisfying color harmony."

After covering his no. 4 charcoal sketch/tonal plan with acetate, Rust painted a color study in oils on it using the underlying drawing as a guide.

2 DRAWING ALL THE ELEMENTS. With the composition and color study worked out, Rust drew each element onto his canvas with pencil or charcoal. "Probably the most important aspect of a painting is the drawing," he says. "It should be accurate in all respects, including correct perspective."

3 BLOCKING IN THE LANDSCAPE. Working with a large bristle brush and a range of middle to dark values, Rust began blocking in the sky. "Normally," he says, "it's easier to paint a blended sky and *then* draw in foreground elements such as the flying pheasants. In this case, however, because of the dark sky, I drew them first and simply painted around the drawing." Rust then completed the major landscape elements, keeping values dark so he could "work up to the light."

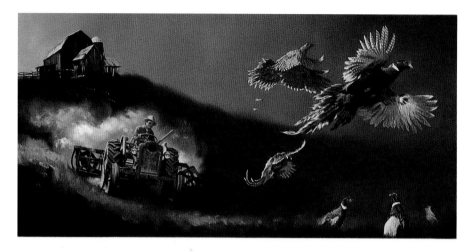

4 ADDING DETAILS. Next, Rust rendered the most detailed areas of the painting. "By covering the entire white of the canvas," he says, "I get a good feel for the setting and can add lights or darks that are appropriate for the mood."

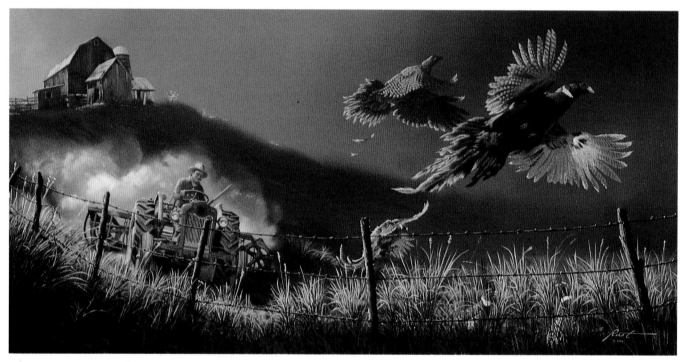

5 ILLUMINATING THE PATH OF VISION. To complete *Ring-necked Pheasants*, Rust painted the fence and illuminated grasses in the foreground. "The most common mistake artists make," he says, "is not planning ahead, but rather jumping right in with paint! I nearly always know in advance exactly how the finished painting will look. This painting, for instance—with the exception of being reversed—is quite close to the original color rough."

"Another common mistake," he says, "is a lack of good tonal or value planning. Poor tonal planning nearly always produces paintings that fail to lead the eye and, generally, lack drama or impact—often important aspects of good art. A black-and-white photograph usually reveals good or poor tonal planning."

Ring-necked Pheasants, 24" × 48"
Oil on canvas, D. "Rusty" Rust

Demonstration Ten

DEVELOPING AN "INTUITIVE" COMPOSITION

PERSIS CLAYTON WEIRS

I do very few preliminary sketches," says Weirs, "because trying to plan a painting in too much detail doesn't really work for me. I change my mind a lot, and as a result, I've learned to let my paintings take on a life of their own. Most of the time, I compose a painting in my mind, then refer to photographs I've taken for details such as lichens, tree bark, snow on branches and lighting effects. In addition, the table near my easel is often littered with dry leaves, branches, twigs, bits of bark, and in this case, even a three-foot section of a spruce tree trunk!"

To accommodate her intuitive approach to composition, Weirs draws a few minimal lines directly onto a gessoed panel to indicate major compositional elements. She retains flexibility well into the painting by roughing in the entire composition loosely, avoiding the temptation to develop details too soon while freely exploring whatever changes come to mind as the composition evolves.

For *Spring Runoff*, Weirs's concept was to focus on the wolf's face and give viewers direct eye contact, as if the wolf had just looked up and realized he was being watched. She chose a vertical format with trees in the foreground to strengthen the vertical design and add a sense of depth. "The trees," she says, "provide a visual 'safe' barrier between the wolf and viewer, making the perspective more believable." Light coming from the upper-right side of the image also adds to the illusion of depth, while ripples and reflections in the foreground water guide viewers' eyes into the image and upwards to the wolf's face. The winter setting allowed Weirs to use a simple palette of predominantly gray tones ranging from dark shadows to filtered sunlight on snow.

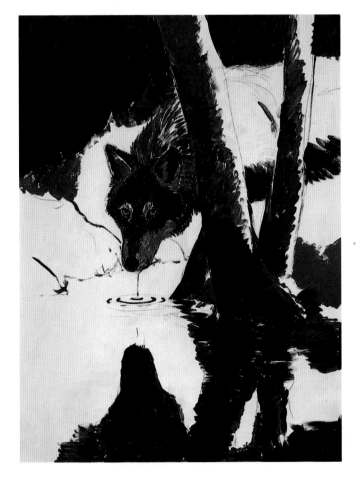

1 BLOCKING IN THE DARKS. Weirs sketched the rough outlines of the wolf and tree trunks directly onto a gessoed panel. After dipping a no. 0 round brush into her basic black mixture (Burnt Umber and Ultramarine Blue) and then into white without mixing, she roughed in the fur with strokes containing both light and dark. These double-loaded strokes stand apart from each other even when they are overlapped.

Weirs quickly set the mood for the scene by painting the wolf's eyes with a pale, greenish gray mixed from Ultramarine Blue, Raw Sienna and white.

Continuing to work with loosely mixed Ultramarine Blue and Burnt Umber, Weirs quickly established the dark values. She modified the left side of the tree with Sap Green and Raw Umber; the right side of the tree trunks remained light to remind her of the light source. "At this point," says Weirs, "I hadn't really decided on the pattern of snowy branches for the tree to the left in the background—basically, I knew I'd just paint white areas of snow over the dark until the pattern intuitively looked right to me."

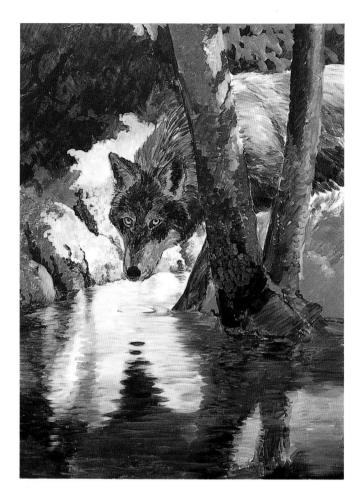

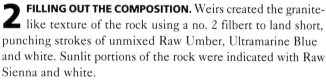

2 FILLING OUT THE COMPOSITION. Weirs created the granite-like texture of the rock using a no. 2 filbert to land short, punching strokes of unmixed Raw Umber, Ultramarine Blue and white. Sunlit portions of the rock were indicated with Raw Sienna and white.

Tree trunks and bark textures were developed using a no. 6 filbert loaded with Burnt Umber, Ultramarine Blue and white, applied in a broken vertical pattern of short, slightly cupped horizontal strokes. The same colors were used to rough in the water and reflections. To sharpen the contrast between wolf and background, shadowed snow was added behind the wolf's ear and neck.

Next, the wolf's shoulder and back were blocked in using a light mixture of Ultramarine Blue, Burnt Umber and white with a touch of Raw Sienna to warm the sunlit fur. Shadowy snow was added at the base of the trees and a darker mixture of the same color was used to suggest snow-covered branches in deep shadow above and behind the wolf.

3 DEVELOPING DETAILS. A small tree was added to the left of the wolf, its twigs and branches guiding the viewers' eyes toward the wolf's head. "I realized," says Weirs, "that the wolf's face was too long and narrow. Shortening the muzzle and putting more distance between the eyes solved the problem." She made certain the hair patterns around the wolf's face went in the correct directions.

Weirs added several small, snow-capped rocks on the left and suggested patterns of water movement by applying strokes of Burnt Umber and Ultramarine Blue over the lighter under-painting.

Spring Runoff,
18″ × 14″
Acrylic on panel,
Persis Clayton
Weirs

4 **MAKING INTUITIVE ADJUSTMENTS.** Even with the major elements of the image established, Weirs continued making intuitive adjustments: The slight bulge in the tree trunk next to the wolf's left foreleg was trimmed to show more of the light water behind it and to separate the foreleg from the tree; the water's edge behind the wolf's muzzle was raised slightly so that the edge and muzzle did not all meet at the same point. Next, she completed the fur in several dark-over-light layers using a no. 0 round brush and mixtures of black, white, Burnt Umber, Raw Umber and Raw Sienna. Sunlit areas were rendered by adding more white and Raw Sienna to the basic fur palette. Strokes were applied to show direction, length and texture of the fur. Finally, a few highlighted hair tips were added to give the coat a believable, rough texture.

The snow-covered branches in the background were finished using a no. 2 filbert loaded with loosely mixed white, Ultramarine Blue and Raw Umber. Several small branches were painted into the foreground to add depth to the composition, and the rock at the left of the wolf's face was topped with green moss to subtly attract viewers' eyes toward the center of interest: the wary eyes of the wolf.

Demonstration Eleven

BUILDING STRUCTURE WITH AN ABSTRACT DESIGN

D A V I D R A N K I N

For Rankin, most paintings begin "in his head" when he sees a subject, a design, or lighting that suggests a particular mood. "I'll see a stork standing in water, and I'm captivated by the stance, the reflections, the sheer abstract quality of the scene." *Morning Bath* began in just that way as a simple pencil sketch some two years before the actual painting took shape. "Having observed a group of sarus cranes near Bharatpur, India, on an earlier visit, I wanted to develop a design based on their typical preening postures," he says. "In my first study I sketched them standing on the ground but almost immediately realized I wanted to work them into a design with strong abstract reflections framing the cranes in early morning light."

Before starting the full-scale painting, Rankin wanted to explore the color possibilities. He scanned his color study (below) into the computer (in color) and used an electronic imaging program called Adobe Photoshop to selectively mask out desired areas and change various colors. "In less than an hour," he says, "I'd tried dozens of color and gradation variations. This took a lot of the guesswork out of the finished painting before I laid down the first wash."

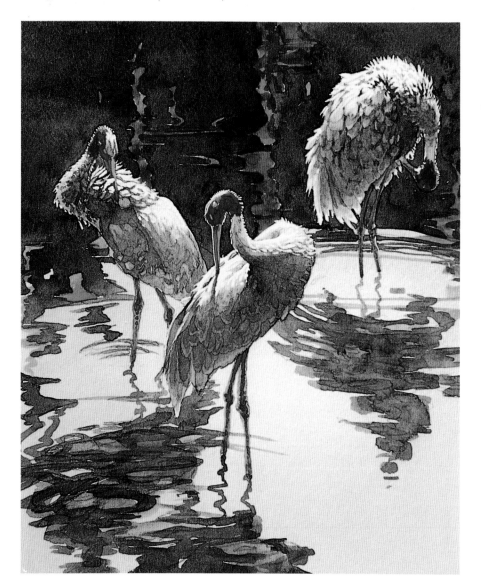

1 COLOR STUDY. Once he had a basic design he liked, Rankin scanned his sketch into a computer and printed out several black-and-white copies. On these, he experimented with several color possibilities before painting this small color study on watercolor paper to take the design process one step further.

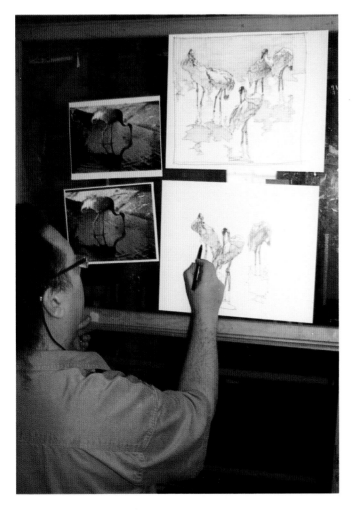

2 **CHECKING THE COMPOSITION.** Not pleased with the vertical format, Rankin experimented with several variations based on a horizontal format. One variation had three cranes; another had five. The final concept included six sarus cranes. "This decision," he says, "was based solely on the overall design and how I wanted the viewer's eye to flow through the painting."

3 **THE BACKGROUND WASH.** Rankin drew his six-bird composition onto cold-press watercolor board and taped it to a slightly larger piece of sturdy plywood. After covering all exposed edges of the plywood with 4-inch clear packaging tape, he carefully premixed large quantities of two wash colors—diluted Indian Yellow and Payne's Gray plus a neutral tint—and prepared the board to receive them by evenly wetting the entire surface with a sponge.

In a process he calls "running a flooded wash," Rankin quickly brushed diluted Indian Yellow uniformly across the surface using a 4-inch wash brush. Next, he painted a band of the Payne's Gray/neutral tint mixture over the bottom third of the paper, and while everything was still "sloppy wet," he stood the board vertically, bottom end up and every other way, causing the gray mixture to literally gravitate down and around the watercolor board and blend smoothly with the yellow.

"The finished result," he says, "is a beautifully even and well-dispersed yellow-to-gray wash with absolutely no brushstrokes or streaks."

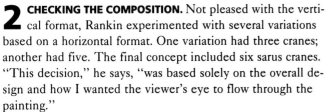

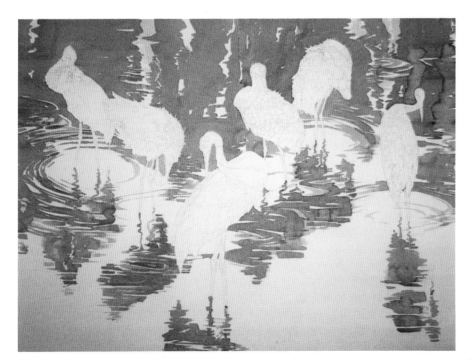

4 **BLOCKING IN THE REFLECTIONS**
Starting in the upper-left corner, Rankin began painting the reflections using a series of chisel-edged brushes. Working down and toward the right, he carefully etched out the shapes of the birds, adding reflections with loose brushstrokes. "I like to achieve a visual sensation of water and reflections with as few strokes as possible," he says. "This not only establishes the mood and value relationships for the painting but also encourages viewers to participate in completing the water."

5 **MODELING THE FIRST CRANE.** Next, working wet-in-wet, Rankin blocked in the first crane, establishing the basic densities and modeling the bird using various mixtures of Payne's Gray and Cerulean Blue. The legs were painted with a mixture of Indian Yellow, Cadmium Pale Red and a neutral tint. For the head, he used a richer blend of Cadmium Red worked over with Payne's Gray and highlighted with a mixture of Cadmium Red and Zinc White gouache. The eyes were rendered with Cadmium Orange while the beaks and reflected lights were warmed with a glaze of Indian Yellow.

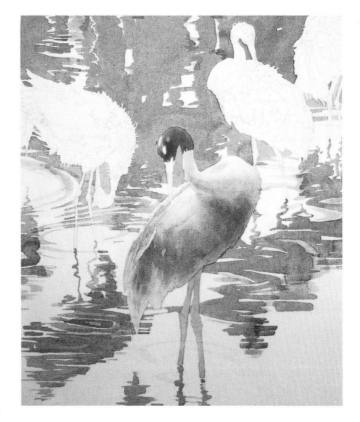

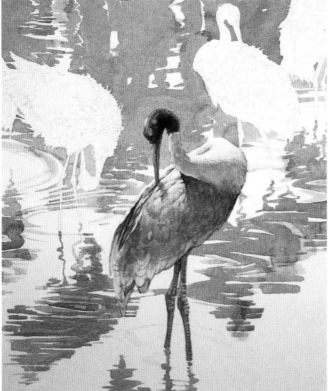

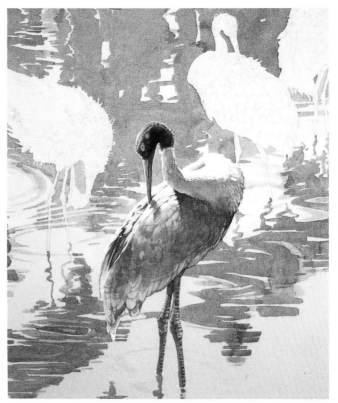

6 **DEVELOPING THE FEATHERS.** With the same color mixtures, he added further details until the first crane had reached a nearly finished state and had begun to create the illusion of depth. Feathers that received the brightest direct light were developed using straight Zinc White gouache. "It's extremely difficult," he says, "to paint highlights such as these without using gouache. I prefer the fine, opaque detail I can build using gouache once I've taken the transparent layers to their maximum effectiveness."

7 **ADDING HIGHLIGHTS.** To complete the first crane, Rankin added the hottest highlights to suggest the bright morning sun on the crane's back using various mixtures of Zinc White and Cerulean Blue gouache.

8 **PAINTING THE OTHER CRANES.** Rankin completed the image by working across the painting, bringing each crane in turn up to full value and then adding final details and highlights.

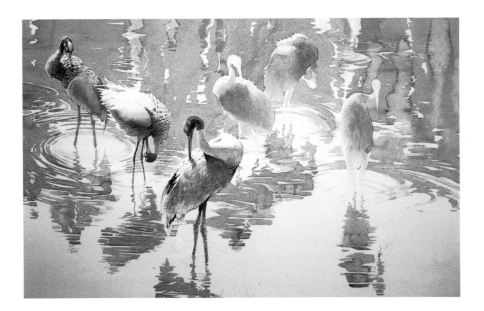

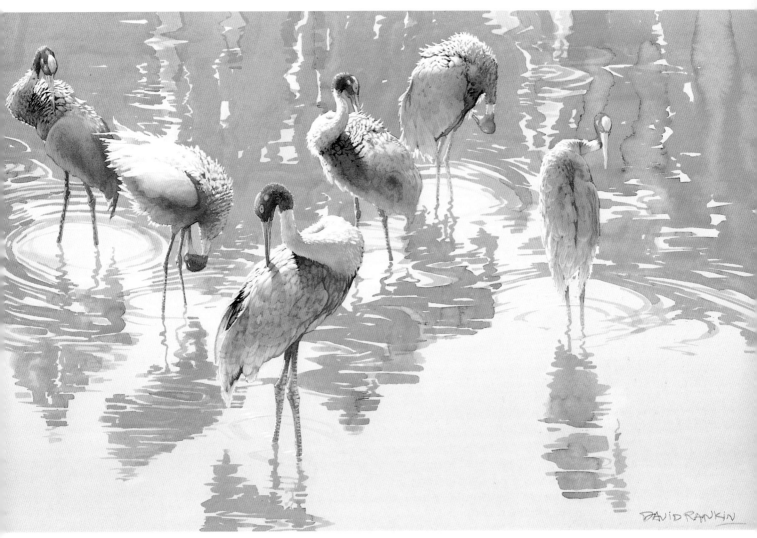

9 **COMPLETING THE PAINTING.** "I consider a painting finished when the value range is correct—when it is what I originally had in mind," he says, "then I know the underlying design will 'read' from a distance in the way I had intended."

Morning Bath, 18″ × 28″
Watercolor, David Rankin

Demonstration Twelve

INTERPRETING THE UNDERWATER ENVIRONMENT

MARK SUSINNO

I'm fascinated both by fish and the subaquatic environment they inhabit," says Susinno. "Depicting them presents unique problems not encountered by artists portraying above-water wildlife."

In order to create credible images of fish and their watery environs, Susinno relies on his own above- and below-water photographs and observations of the activities and locations of his elusive subjects, and on extensive knowledge gained through sport fishing. "Whatever I give up in accessibility," he says, "I gain in compositional freedom. I have the liberty of interpreting my subject by arranging compositional elements according to the principles of good design and by having a wide latitude in color options, rather than being locked into a limited range of colors as many of my above-water counterparts are."

To create *Susquehanna Smallmouth*, Susinno conferred with another experienced fisherman. "In reality," says Susinno, "when a bass's mouth is open as wide as I've depicted it in *Susquehanna Smallmouth*, the prey or lure would already have been sucked into its mouth. But, painting the scene with such literal accuracy doesn't create a particularly intelligible image, so I chose to bend the rules and portray the fish as if it were swimming after its prey with its mouth agape."

1 UNDERPAINTING ON PANEL. After drawing a series of thumbnail sketches on lined notebook paper, Susinno transferred his drawing onto a gessoed panel and applied a fairly uniform underpainting mixed from Red Iron Oxide, Cadmium-Barium Yellow Deep and Titanium White. For the smallmouth bass, he used the same mixture in wash fashion to sketchily model the form.

COLORS USED FOR FISH

- Greenish Umber
- Red Iron Oxide
- Permanent Green Light
- Hansa Yellow Light
- Dioxazine Purple
- Cadmium-Barium Yellow Deep
- Cadmium-Barium Orange
- Titanium White

BACKGROUND COLORS

- Red Iron Oxide
- Cadmium-Barium Yellow Deep
- Cadmium-Barium Orange
- Permanent Green Light
- Dioxazine Purple
- Hansa Yellow Light
- Titanium White

2 **BLOCKING IN THE COLORS.** Susinno quickly established an approximation of the painting's overall color scheme and value structure. Using a tattered no. 2 white sable brush, he added detail to the fish and painted the foreground gravelbar, allowing the reddish underpainting to show through. As he painted the upper portions of the background he added more yellow and white to the mixture to suggest light coming from above.

Concerning the bass's underbelly, jaw, and gill membrane areas, he says, "I like using Permanent Green Light and Dioxazine Purple for mixing grays because by varying the ratio of the two colors, I can change the cast of the gray from bluish to pinkish. A little yellow kept the mixture from contrasting too strongly against the background." Many of the membranes, fins and scales are translu-

cent, and the warmer underpainting visible beneath the cooler grays helps suggest the smallmouth's blood flow. "This warm/cool contrast," says Susinno, "makes the fish look more alive."

3 **FIRST SCALES.** Susinno began indicating the smallmouth's scales by applying dabs of color in uneven horizontal rows using a mixture of Cadmium-Barium Yellow Deep, Cadmium-Barium Orange and Permanent Green Light. "Painting scales," he says, "is difficult. A particular species' scales are arranged in a way characteristic of that species and quite unlike the pattern of similar-looking but unrelated species. Also, the scales must describe, via proper perspective, the three-dimensional volume and body position of the fish." This means that lines converge into the illusory depth of the image and that the relative size of scales must reflect not only natural size variations but also the reduction in size attributable to perspective. Furthermore, if the scales of a fish run in reasonably straight lines when it's at rest, they'll become curved lines as it swims when viewed from slightly above or below.

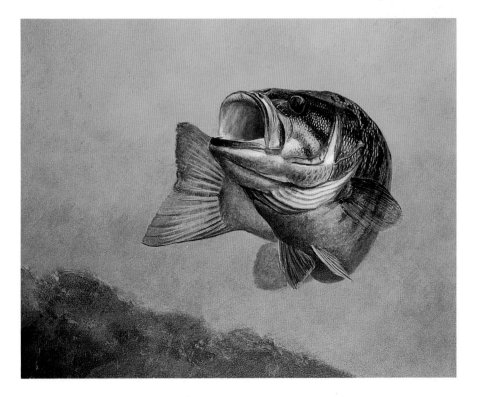

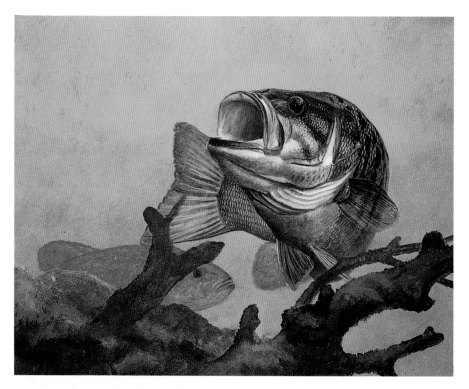

4 **ORIENTING THE SUBJECT IN SPACE**
"I added several submerged tree branches where I'd be able to place a couple of broken-off lures," says Susinno. "I felt they would orient the fish in space, as would another fish just behind the main subject." After drawing a second fish on tracing paper and moving it around to find the best position, he transferred the outline onto the panel and painted it in. Then, with a white pencil, he sketched possible shapes and positions for each of the branches directly onto the panel, erasing any he didn't like. Settling on a composition of overlapping diagonals, he painted the two branches using a mixture of Greenish Umber, Red Iron Oxide, Cadmium-Barium Yellow Deep, Titanium White and Cadmium-Barium Orange.

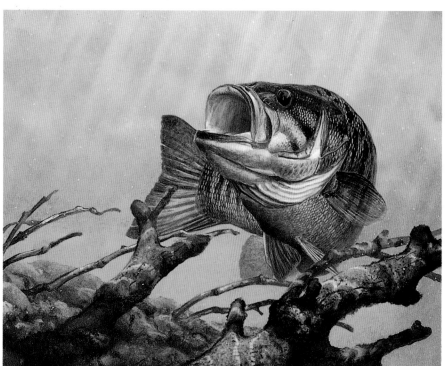

5 **CREATING A BELIEVABLE ENVIRONMENT.** Realizing that the second fish made the painting bottom heavy, he painted it out. "From this point on," says Susinno, "the work was more enjoyable—I'd arranged all of the elements in a sort of 'shadow box'; now I simply needed to bring some elements forward and push others back to create a believable space."

After lightening the top of the weedbed, he began illuminating the foreground branches with the distinctive crisscrossing lines produced by sunlight filtering through the water's rippled surface. For these, instead of pure white, he used a prismatic range of closely related colors (for example, orange, then a warm yellow, then a darker and greener yellow). Next, he added suggestions of suspended sediment throughout the background followed by suggestions of downward streaks of light (painted somewhat oranger on the light side and bluer on the opposite side). Finally, he added a few weed stems and refined details of the fish, branches, mud and rocks in the weedbed.

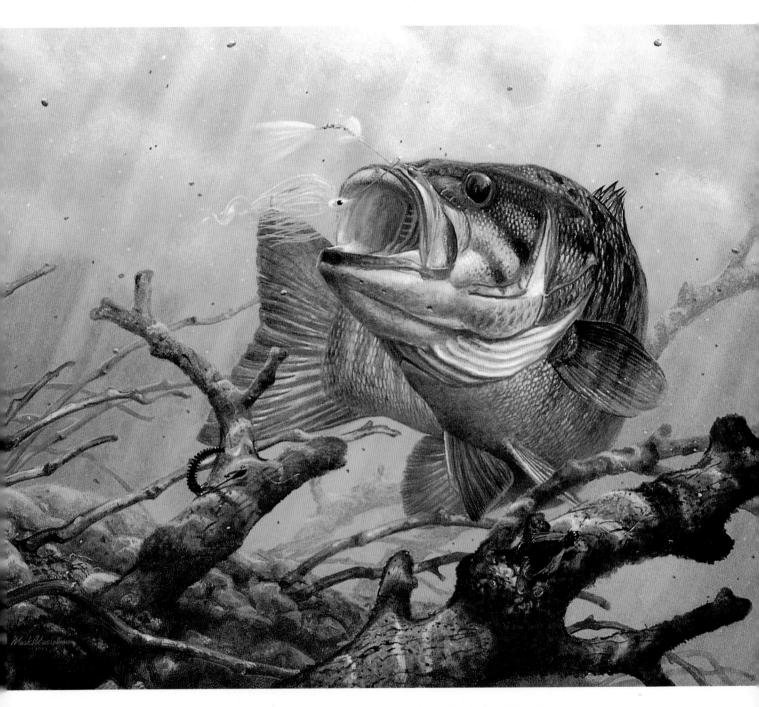

6 **ADDING FINAL DETAILS.** To complete the painting, Susinno applied a lighter color to upper portions of the background to heighten contrast and applied a wash of the background color over the fish's tail to make it recede a bit more. He also added more stems and several less-distinct branches. Finally, he added the monofilament line, the spinnerbait (ahead of the bass's gaping mouth), and the broken lures (snagged in the branches in the lower portions of the painting).

Susquehanna Smallmouth, 16" × 20"
Acrylic on gessoed panel, Mark Susinno

ABOUT THE ARTISTS

PAUL BOSMAN

Born in South Africa, Paul Bosman spent his early years in the Great Karroo, an area bearing a striking resemblance to the Sonoran desert of Arizona. Educated at St. Andrews College, the Johannesburg School of Art, and the Central School of Art in London, he pursued a successful career in advertising and subsequently operated a photographic safari lodge before becoming a full-time wildlife artist.

"Wildlife has always fascinated me," says Bosman, "and I've been fortunate to have had ample opportunity to study it. As a child, I rode the South African 'veld' on horseback and became familiar with blue cranes, ostriches, springbok, mountain zebra, hartebeest and meerkats. Later, when my father became Director of Agriculture in Botswana, I was exposed to many new species of birds as well as lions, leopards, buffalo, rhino and antelope. At around age forty, my wife and I moved to Zimbabwe where we built and operated a photographic safari lodge. There, elephants, buffalo and lions were to us what the neighbor's cats and dogs had been in the city."

During a long and varied career, Bosman has designed wildlife postage stamps for South Africa, Namibia and Bophuthatswana, and his paintings have been shown internationally in numerous exhibitions including "Animals in Art" at the Royal Ontario Museum in Canada. In 1982, Bosman and his family emigrated to the United States and since then, his work has appeared in many shows including the Society of Animal Artists exhibits for 1987, 1990, 1991 and 1993 (at which he received four Awards of Excellence).

In addition to limited edition prints of his work published by Wildlife Investment, Inc., and Applejack Publishing, Bosman has provided paintings and line drawings for a number of books including *Elephants of Africa* (Struik, South Africa), *Arizona Game Birds* (University of Arizona Press), *Cats of Africa* (in publication), and *The Magnificent Seven* (Human and Rousseau, South Africa). The latter book depicts the seven largest "tuskers" in South Africa's Kruger National Park.

Bosman maintains his home and studio in Sedona, Arizona. His original paintings are represented by Gallery of the West (Sedona, Arizona, and Jackson Hole, Wyoming) and by Nelia van Velden, Colors of Africa (Johannesburg, South Africa).

Taking the Sun, 9″ × 12″
Pastel, Paul Bosman

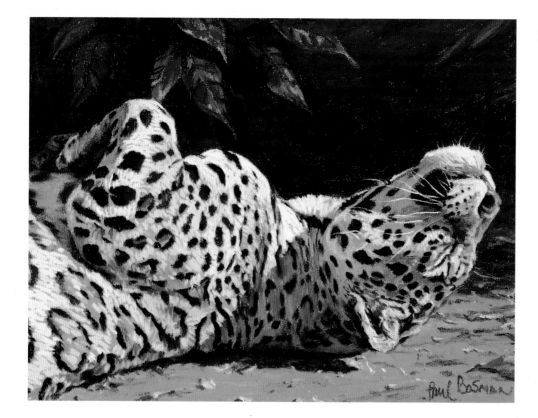

LUKE BUCK

"I was primarily a landscape painter," says Luke Buck, "but after my first trip to Florida in 1983 and my introduction to its magnificent wading birds, I was fascinated. Still, despite my enthusiasm, my first paintings of wading birds felt awkward. It took time, patience and discipline to learn to capture not only their anatomy, but also the distinct personalities of each type of bird."

That enthusiasm and love of wading birds lures him to southern Florida each winter where he sketches, paints and exhibits his work all across the state. A recipient of numerous awards and honors, he has been a professional artist since 1959. A second-generation artist, Buck has extensive experience in many mediums, although his current work is executed primarily in gouache and watercolor. "Techniques can be loose or tight," he says, "but there must be enough 'life' in a painting to involve viewers." He accomplishes this by contrasting accurate details against strong, free-flowing watercolors and by careful attention to traditional artistic principles of design, color and balance.

"For me," he says, "the most difficult aspect of wildlife painting is also the most enjoyable—getting good reference. If you aren't afraid to get cold, wet or muddy, you should have no problem getting subject matter."

Luke and his wife, Coleen, maintain a home and studio at the couple's lakefront home in southern Indiana.

Curiosity, 30″ × 40″
Watercolor, Luke Buck

DON ENRIGHT

Don Enright grew up in southern Wisconsin in the dairy community of Elkhorn where he spent much of his childhood hunting, fishing, and roaming the woods and fields. Flocks of ducks and geese that migrated through the area provided inspiration for many of his earliest efforts as a wildlife artist.

Later, Enright studied commercial art at the American Academy of Art, the Studio School of Art, and at the Institute of Design in Chicago. "While in art school," he says, "I was discouraged from pursuing my interest in painting wildlife by an instructor who said there just wasn't enough market for wildlife art." After graduation, Enright worked in advertising for a few years in Chicago before moving west to enjoy the open spaces and vast expanses of Colorado. For the next nineteen years, he worked as an artist and Art Director for the Navigators, an international Christian organization. He began painting full-time in 1975 immediately following his return from a trip to photograph wildlife in Africa.

Since then, his works have won numerous awards including Best of Show—Animals at the National Wildlife Show in Kansas City (1979), Best Mountain Sheep and Best Mule Deer at the Tulsa Wildlife Art Festival (1980), Painting of the Year and first place in watercolor at the New Mexico Wildlife Federation Exhibit in Albuquerque (1982), and Best of the Big Cats at the Tulsa Wildlife Art Festival (1983). Enright's painting *Fall Mules* (mule deer) won an Honorable Mention in the 1992 *The Artist's Magazine* Wildlife Art competition, and his work is featured in *Splash III*, an anthology of watercolorists' works published by North Light Books.

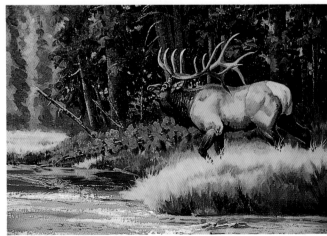

Park Royalty, 18″ × 24″
Oil, Don Enright

CHARLES FRACÉ

"When I began painting wildlife more than thirty years ago, I put every effort into the accuracy and detail of my animal subject and its habitat," reveals Charles Fracé. "Today, as so many species have declined, I strive to make my art have an impact on others. In the subjects I choose and the scenes I paint, I hope to create awareness of our natural treasures that are so rapidly vanishing."

Since the release of his first limited edition print in 1973, Fracé's art has been featured in nearly five hundred one-man shows at galleries and museums across the country. In 1992, he was honored with a one-man exhibit at the National Museum of Natural History of the Smithsonian Institution in Washington, D.C. ("The American Wildlife Image and Charles Fracé," November 1992 - May 1993).

Charles Fracé has been recognized by *Who's Who in American Art*, as well as other art, wildlife and honorary societies. One of Fracé's proudest accomplishments is The Fracé Fund For Wildlife Preservation, which he established in 1993 to provide financial support for deserving wildlife organizations. His art and life have been profiled in two books, *The Art of Charles Fracé* and *Nature's Window—Charles Fracé*, as well as national publications such as *U.S. Art* and *Wildlife Art News*.

His limited edition prints have been eagerly and consistently collected for more than twenty years. They are now published exclusively by Somerset House Publishing, Houston, Texas.

Fracé maintains his home and studio in a suburb of Nashville, Tennessee, where he lives with his wife, Elke.

LESLEY HARRISON

"I'm a self-taught artist," says Harrison, "so I never learned that the type of paintings I create are supposed to be impossible. I sometimes think there's no way this image will ever work. It goes through such ugly stages that I get discouraged and scared—but I keep working because I know from experience that eventually it will work. So, I'll spend hours on a single square inch of a pastel if that's what it takes to get it right."

Harrison's perseverance carries into her research as well. In addition to observing subjects in the wild, Harrison has spent years building a network of friends including zoo officials, wildlife biologists, and owners of exotic animals that has enabled her to get to know her subjects intimately. "Most people," she says, "will probably never experience what it feels like to hold a two-month old snow leopard in your arms, bottle feed a newborn fawn, or pet a mountain lion and hear it purr. One of the reasons I paint is to share those experiences with others."

Harrison has completed equine and wildlife commissions for many prominent collectors including filmmaker George Lucas. In 1988, she received the "People's Choice Award" from the Kentucky Derby Museum. Harrison is a member of the Pastel Society of America and the Pastel Society of the West Coast. Her work is exhibited at Trailside Galleries (Jackson Hole, Wyoming, and Carmel, California) and at Big Horn Gallery (Cody, Wyoming).

Harrison lives and paints in a rural area near Carmel, California, where she owns two horses and an assortment of adopted pets.

Ocelots, 18" × 20"
Oil, Charles Fracé

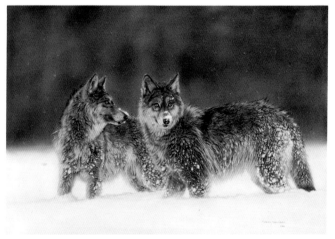

Belongs to the Wild, 18" × 24"
Pastel, Lesley Harrison

KARL ERIC LEITZEL

"My family and I live in a rustic house we built for ourselves in the woods," says Leitzel. "We have no electricity or running water, but our location constantly rewards us with a close relationship with the natural world. On daily walks to a small mountain stream for buckets of water, I've seen deer, turkey, ruffed grouse, gray foxes, minks, skunks, porcupines, rabbits and a host of squirrels, snakes and songbirds."

Born in 1957, Karl Eric Leitzel has spent most of his life in rural areas around central Pennsylvania. Although he had sketched and painted since childhood and briefly exhibited paintings of various subjects in the mid-1970s, it wasn't until 1991 that he resumed his painting career, this time concentrating specifically on wildlife art.

Leitzel has worked with and contributed to the Shaver's Creek Environmental Complex and Raptor Rehabilitation Center located near the main campus of Pennsylvania State University. His painting of a bobcat titled "Turning on a Dime" recently won a place on the Indiana Department of Natural Resources "Hoosier Outdoor Calendar" for 1994-1995. In addition, his painting, "Assateague Feeding Grounds," was selected for inclusion in the Leigh Yawkey Woodson Art Museum's 1994 "Birds in Art" exhibition.

Karl Eric Leitzel lives with his wife and two daughters near the rural community of Spring Mills, Pennsylvania. The family keeps a garden along with a flock of chickens and several milk goats. A wood stove and gas lights provide a snug home when the winter winds howl.

DANNY O'DRISCOLL

Danny O'Driscoll, who grew up in South Carolina's "low country" surrounded by wildlife, had begun drawing birds by his tenth birthday. After attending the College of Charleston, he spent the next six years working as a graphic artist for the Riverbanks Zoo in Columbia.

"Every day," says O'Driscoll, "I painted exotic birds and animals of all descriptions and, as I perfected my technique, I also expanded my knowledge of ornithology." O'Driscoll's stint at the Riverbanks Zoo was followed by a similar position at the Houston Zoo where, for the next five years, he was asked to depict even more unusual species of reptiles, snakes and even tropical fish.

In 1982, O'Driscoll set out on his own and has been a successful full-time artist ever since, exhibiting his paintings at prestigious wildlife exhibitions from Anchorage, Alaska, to New York City. He recently completed a series of eight collector plates featuring American songbirds for the Hamilton Collection. His paintings have won awards from the American Association of Zoological Parks and Aquariums, the South Carolina Wildlife Federation, the Spoleto Art Festival (Charleston, South Carolina), and the Southern Wildlife Art Show (Decatur, Alabama) where he won both Best of Show and First Place awards in 1993. In addition, Lightpost Publishing of San Jose, California, will soon begin offering limited edition prints of his paintings.

O'Driscoll and his artist-wife, Mundina, live and paint in Batesburg, South Carolina.

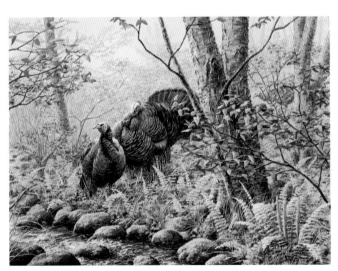

Wild Turkeys and Cinnamon Ferns, 18" × 24"
Acrylic on gessoed panel, Karl Eric Leitzel

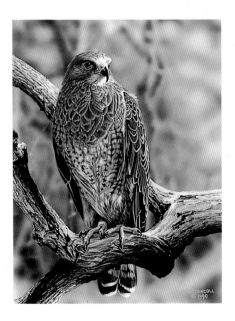

Swainson's Hawk, 14" × 11"
Acrylic on gessoed panel
Danny O'Driscoll

DAVID RANKIN

"My primary focus is the wild-life of India—a subject I began studying when I was living with my guru in a small yoga hermit-age in the Himalayas," says art-ist David Rankin. "Since my first trip in 1970, I've returned many times to gather additional reference for my work."

A graduate of the Cleveland Institute of Art, he notes that India, with a land area only one-sixth the size of North America, hosts the second largest biodiversity of birds in the world—more than twice that of the United States and Canada combined. To convey what he has experienced via his art, Rankin employs a style he calls "natural abstraction" in which he develops realistic subjects based on abstract design principles he finds in nature.

Rankin's work is in the permanent collections of the Leigh Yawkey Woodson Art Museum (Wausau, Wisconsin), the International Crane Foundation (Baraboo, Wisconsin), and the Cleveland Metropark Zoo. His work has been profiled in *International Wildlife*, *Wildlife Art News*, and *American Artist's Watercolor '94* and has appeared in national exhibitions including the Society of Animal Artists Annual Exhibition as well as in the Leigh Yawkey Woodson Art Museum's *Birds in Art* (1990, 1991, 1993 and 1994), and *Wildlife: The Artist's View* (1991 and 1993).

Rankin, who lives and paints in Cleveland, Ohio, is a member and vice president of the Society of Animal Artists and is on the board of the International Society of Endangered Cats. He actively supports a wide range of projects in education, health and community development and has created paintings for a number of wildlife conservation organizations.

Bachelor Hornbills, 38″ × 58″
Watercolor, David Rankin

BART RULON

Since graduating with honors from the University of Kentucky in 1990 with a degree in scientific illustration, Bart Rulon has eagerly pursued his dual interests in wildlife and painting. "I don't always enjoy painting, but I do enjoy being outdoors in wild places searching for and watching wildlife in their natural habitat. Fortunately, being able to share my observations and experiences through my art is enough to pull me through the predictable frustrations and difficulties of painting."

Rulon's paintings have appeared in numerous national showcases, including the Leigh Yawkey Woodson Art Museum's *Birds in Art* exhibitions for 1992-94 and their *Wildlife: The Artist's View* exhibition and subsequent tour in 1990. In addition, his works were selected for inclusion in the Arts for the Parks Top "100" Exhibition and tours for 1991, 1992 and 1994, and for the Society of Animal Artists' *Art and the Animal* exhibition for 1993 and 1994. His works are in the collections of the University of Kentucky Museum of Zoology and in the Leigh Yawkey Woodson Art Museum and its John and Alice Woodson Forester Miniature Collection.

Rulon's paintings have appeared in *Bird Watcher's Digest*, *Current Ornithology*, and as illustrations in *The Zoology Lab Manual* (Kendall Hunt Publishing Co.). In addition, Bart Rulon is one of five artists completing paintings for *A Guide to the Birds of the West Indies* (Princeton Press) and is the author of *Painting Birds Step by Step* (North Light Books, 1996).

"Physical accuracy of the animal and its environment are prerequisites for good wildlife art," says Rulon, "but the very best wildlife paintings have a lasting impact because they also evoke an emotional response in viewers."

Rulon is a member of the Society of Animal Artists. He maintains his home and studio in Greenbank, Washington.

Searching in the Crevices, 30″ × 20″
Acrylic, Bart Rulon

D. "RUSTY" RUST

"There are a lot of problems affiliated with wildlife painting," says Rust. "It's often difficult finding and reaching wildlife in its natural habitat, whether for observation or photography. It's not always fun in Florida when you're slogging through swamps, but it makes your work more interesting when you really know the wildlife and locale."

During his years as an artist, Rust has tromped through many swamps in the course of assembling a reference library of over 250,000 slides, along with thousands of photographs and clippings, all of which he has carefully cataloged and filed according to subject. In acquiring that reference, Rust has had a bout with Lyme disease and numerous close encounters with assorted spiders, scorpions, alligators and rattlesnakes. "A lot of artists sit in front of a blank canvas and try to 'create' something," says Rust, "but they can't depict it because they've never been to the locale."

A prolific artist with over 14,000 paintings to his credit, Rust has paintings in the Smithsonian's National Portrait Gallery, the Norman Rockwell Museum, and the Ringling Museum of the Circus. His paintings have appeared in numerous publications including *Reader's Digest*, *Wildlife Art News* and *Florida Wildlife*. His paintings have been reproduced on a host of greeting cards, calendars, collector plates, shopping bags, T-shirts, candy boxes, playing cards and jigsaw puzzles.

Born in Erie, Pennsylvania, Rust has lived in Sarasota, Florida, since 1954.

Alligators, 48" × 36"
Oil, D. "Rusty" Rust

RANDALL SCOTT

"While growing up, I was an avid fan of *Sea Hunt* and the Jacques Cousteau specials," says Scott. "I was also a regular visitor at local aquariums and learned to snorkel and scuba dive at an early age. As a child, I constantly drew whales, fish and dinosaurs. Later, when I began thinking of earning a living from art, it was suggested to me that I paint more salable subjects, but I felt there might be a market for paintings of sea life someday because so few artists were focusing on it at the time."

To supplement his firsthand experiences as a diver, Scott studied art and marine biology at Palomar College. In 1985, he was named "Artist of the Year" by the National Coalition for Marine Conservation—Pacific Region for a painting depicting a pair of regal kelp bass. Since then, one of his paintings has been included in the Leigh Yawkey Woodson Art Museum's "Wildlife—The Artist's View" 1993 exhibit and subsequent tour, and he was selected as the San Diego Ocean Foundation's 1994 "Artist of the Year." His original paintings and limited edition prints are available through Wild Wings of Lake City, Minnesota.

"By combining art with diving, I'm able to travel widely and make a living doing what I enjoy most," says Scott. "When I'm diving, I never know what I'll experience—anything from the sheer awe of watching a large shark pass close by, to the absolute thrill of interacting with a group of dolphins or the pleasure of witnessing an underwater ballet of seals. Being able to capture that vision on canvas is by far the greatest reward."

Scott lives and works in Escondido, California.

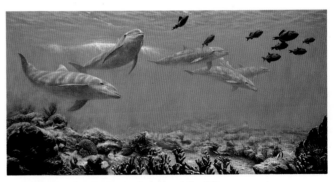

Caribbean Locals—Bottlenose Dolphins, 26" × 53"
Acrylic, Randall Scott

MARK SUSINNO

A native of Maryland, Mark Susinno graduated with honors from Pratt Institute in Brooklyn, New York. "Having taken many diverse approaches to painting while in college—everything from tight realism to nonobjective paintings, wall constructions and sculpture," says Susinno, "I found myself years later without much motivation to pursue any particular direction in my art." So, after college, Susinno turned his hands instead to a variety of jobs ranging from truck driver to bullet-proof door fabricator.

"As I began losing interest in doing manual labor for the rest of my life," he says, "I learned about the waterfowl and trout stamp contests and began entering various state competitions and the Federal Duck Stamp contest." In just four years, Susinno had won six state stamp competitions. Thus far he has racked up wins in thirteen state fishing stamp contests and has placed in the top twenty-five in the Federal Duck Stamp contest.

Twenty-three of Susinno's paintings have been published as limited edition prints, and another group of his paintings was used for a collector plate series produced by the Hamilton Collection. Susinno's work has appeared in many national and regional publications including *Field & Stream, Wildlife Art News, Sporting Classics, Fishing World, Trout* and *The Fly Fisher.* His painting "Pandemonium—Striped Bass" was included in the Leigh Yawkey Woodson Art Museum's 1993 *Wildlife: The Artist's View* exhibit and subsequent tour.

Susinno, who considers himself a "fanatic" fisherman, is a board member of the Seneca Valley Chapter of Trout Unlimited and a member of both the Potomac River Smallmouth Club and the Smallmouth Bass Foundation.

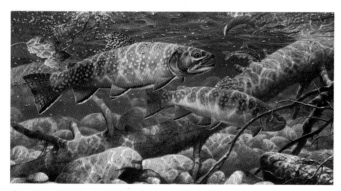

Sparkling Headwaters—Brook Trout, 12" × 22"
Acrylic, Mark Susinno

PERSIS CLAYTON WEIRS

"I live in a rural area on an island in Maine," says Weirs, "so I can be in the woods in thirty seconds or on the shore in five minutes. I don't usually have to go far to find something that sparks an idea for a painting—a new snowfall, golden afternoon light, fall colors, interesting cloud formations, early morning mist or a sunrise."

Although she had no formal art training, Weirs's interest in painting began at an early age as an outgrowth of her love of horses. She got her first horse at age sixteen, and he remained with her for thirty-three years. For the first twelve years of her career, horses were a favorite subject. Later, the scenic diversity of Maine inspired her to broaden her subject matter to include sea and landscape and, of course, wildlife. Since then, she has sold more than five hundred original paintings, and about forty of her images have been published as limited edition prints by Wild Wings of Lake City, Minnesota.

Weirs's paintings have been included in the Leigh Yawkey Woodson Art Museum's "Birds In Art" exhibition on five separate occasions, and one of her paintings won the Maine Migratory Waterfowl Stamp Contest in 1992. In addition to being a featured wildlife artist at the Milwaukee Sports Show in 1994 and an instructor at the Acadia '94 Symposium, she participated in the Southeastern Wildlife Expo for 1993 and 1994. She has also exhibited at the Wildlife and Western Art Exhibition (Minneapolis) from 1991-1994 and at the Wild Wings Fall Festival from 1988-1994.

Weirs maintains her studio and home in Maine where she lives with her husband and family, "a houseful of cats surrounded by an assortment of horses, ponies, sheep and a dog named 'Misty' who is half dalmation and half couch potato."

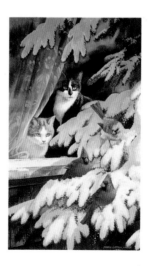

Bird Watchers, 24" × 15"
Acrylic, Persis Clayton Weirs

WILDLIFE ORGANIZATIONS AND PUBLICATIONS

Here are just a few of the many organizations and publications that can be of assistance to wildlife artists. The information in this list was current at the time of publication; however, it is possible that certain addresses or phone numbers may change. Since it is not only likely but highly probable that fees for memberships and various publications will go up, please check with the organizations listed for current rates. If you have difficulty contacting any of these organizations at the addresses or phone numbers given, ask the reference librarian at your local library to help you locate current information in one of the many directories that are updated annually.

MUSEUMS
Leigh Yawkey Woodson Art Museum
700 N. Twelfth St.
Wausau WI 54401
(715) 845-7010

Features permanent exhibits of outstanding historic and contemporary wildlife art. Sponsors annual juried *Birds in Art* competition, exhibition and subsequent tour. Also sponsors the triennial juried *Wildlife: The Artist's View* competition, exhibition and subsequent tour. Color catalogs of current and past exhibitions are available from the museum for a fee.

MAGAZINES
Audubon
National Audubon Society
950 Third Ave., New York NY 10022

Birder's World
720 E. Eighth St., Holland MI 49423

Bird Watcher's Digest
P.O. Box 110, Marietta OH 45750-9962

In-Fisherman
Two In-Fisherman Dr.,
Brainerd MN 56401

National Wildlife
8925 Leesburg Pike, Vienna VA 22184

Outdoor Photographer
P.O. Box 50174, Boulder CO 80321-0174

Articles on wildlife photography techniques. Advertisements for wildlife photographic tours, etc.

South Carolina Wildlife
P.O. Box 167, Columbia SC 29202

Texas Parks & Wildlife Magazine
4200 Smith School Rd., Austin TX 78744

Trout
1500 Wilson Blvd., Arlington VA 22209

U.S. ART
12 S. Sixth St., Suite 400,
Minneapolis MN 55402

Wildbird Magazine
2401 Beverly Blvd., Los Angeles CA 90057

Wildlife Art News
P.O. Box 16246,
St. Louis Park MN 55416-0246
(612) 927-9056

Features articles profiling wildlife artists worldwide. Lists upcoming wildlife exhibits and events. Occasional classified advertisements from professional photographers willing to sell their images for reference.

ARTIST'S ORGANIZATIONS
Society of Animal Artists
47 Fifth Ave.
New York NY 10003
(212) 741-2880

Founded to promote fellowship among wildlife artists and to further the development of animal art as a contemporary fine art form. Membership is by jury. SAA sponsors *Art and the Animal* and other juried wildlife art shows annually. Publishes *Catasus* and newsletters to keep members informed of news as well as upcoming events and opportunities.

Guild of National Scientific Illustrators (GNSI)

P.O. Box 652, Ben Franklin Station
Washington DC 20044
(301) 762-0189

This organization covers medical and biological illustration more than fine art; however, many members paint or illustrate wildlife for publications such as field guides or textbooks. GNSI hosts an annual summer workshop that typically includes instruction subjects such as using an airbrush or using colored pencil to sketch animals at the zoo. A bimonthly newsletter discusses techniques and announces artistic opportunities.

OTHER WILDLIFE ORGANIZATIONS
American Cetacean Society
P.O. Box 2639
San Pedro CA 90731-0943

Oldest whale protection organization. Membership includes subscription to quarterly *Whalewatcher* magazine about whales, dolphins and porpoises.

Black Bass Foundation
260 Crest Rd.
Edgefield SC 29824

Ducks Unlimited
One Waterfowl Way
Memphis TN 38120
(800) 453-8257

Many local chapters across the country. Many have art exhibits along with their annual meetings.

Foundation for North American Wild Sheep
720 Allen Ave.

Cody WY 82414
(307) 527-6261

Many local chapters. Many have art exhibits with their meetings.

International Crane Foundation
E-11376 Shady Lane Rd.
Baraboo WI 53913
(608) 356-9462

National Audubon Society
950 Third Ave.
New York NY 10022
(212) 832-3200

Among its goals: long-term protection and wise use of wildlife, land, water, and other natural resources. *Audubon,* the organization's monthly magazine, covers ecological and wildlife issues. A bimonthly newspaper, the *Audubon Activist,* is devoted to current environmental issues.

Rocky Mountain Elk Foundation
P.O. Box 8249
Missoula MT 59807-8249
(406) 523-4500

Established to accomplish for elk what various conservation organizations have achieved for other wildlife species such as turkeys, trout, wild sheep and waterfowl. Publishes *Bugle,* a full-color magazine featuring articles about wildlife conservation and the role of hunting in managing elk and other big game populations. Sponsors an "Artist of the Quarter" program.

The Ruffed Grouse Society
451 McCormick Rd.
Coraopolis PA 15108
(412) 262-4044

Dedicated to improving the environment for ruffed grouse, American woodcock and other forest wildlife. Publishes the *Ruffed Grouse Society* magazine five times annually.

Trout Unlimited
1500 Wilson Blvd.
Arlington VA 22209
(703) 522-0200

Goal: "To conserve, restore, and enhance North America's trout, salmon and steelhead—the ultimate indicators of good water and habitat quality." Publishes two quarterly full-color magazines: *Trout* and *Action Line.*

The Whale and Dolphin
Conservation Society
191 Weston Rd.,
Lincoln MA 01773

Society works toward the total abolition of all scientific and commercial whaling. *Sonar,* its full-color magazine published twice annually, periodic newsletters, and *International Whale Bulletins* contain photographs depicting and elaborating on whale and dolphin behavior.

The Wilderness Society
1400 I St., N.W.
Washington DC 20035

Watchdog of public land usage with focus on federal public lands: National Parks, National Forests, National Wildlife Refuges, and Bureau of Land Management areas. Publishes *Wilderness,* a quarterly magazine plus direct mailing to alert members to current environmental issues.

World Wildlife Fund
1250 Twenty-Fourth St., N.W.
Washington DC 20037
(202) 293-4800

Helps assess areas of ecological concern and attempts to achieve practical and sustainable solutions. Member contributions fund habitat management, maintenance and protection as well as research and distribution of information. Publishes newsletters, bulletins and brochures to keep public abreast of its efforts. Works with artists in fund-raising efforts.

USEFUL PUBLICATIONS

National Wildlife Refuges: A Visitor's Guide
c/o Superintendent of Documents
Government Printing Office
Washington DC 20402
(202) 783-3238

National Wildlife Refuges: A Visitor's Guide contains a map of the United States with names, addresses and locations of all national wildlife refuges plus a list of available activities for each. Fee $1.00

WILDLIFE REHABILITATION AND RESCUE CENTERS

At the time of publication, no national organization or directory of these facilities could be located; however, your local zoo, veterinarian or state wildlife department should be able to assist you in finding such organizations in your area.

INDEX